W9-CDT-104

.W7344
A4
2000

The Art of Ellis Wilson

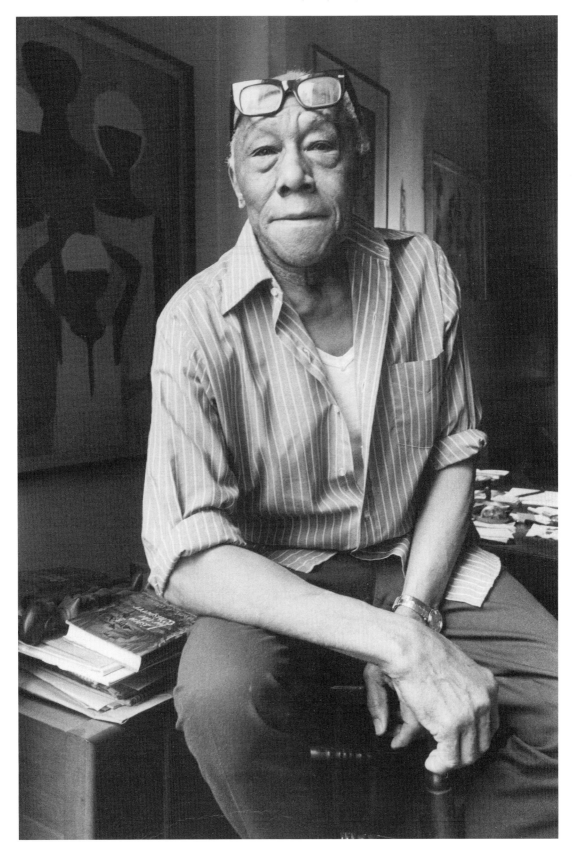

BELL LIBRARY - TAMU-CC

The Art of ELLIS WILSON

Albert F. Sperath
Margaret R. Vendryes
Steven H. Jones
Eva F. King

TOURING ITINERARY

Murray State University Clara M. Eagle Art Gallery,
Murray, Kentucky
February 14–March 14, 2000
University of Kentucky Art Museum, Lexington, Kentucky,
April 8–June 25, 2000

THE UNIVERSITY PRESS OF KENTUCKY

Publication of this volume was made possible in part by a grant from the National Endowment for the Arts, the National Endowment for the Humanities, and support from Murray State University (MSU) office of the President, MSU office of the Provost, Kentucky African American Heritage Commission, MSU College of Fine Arts and Communication, MSU College of Humanistic Studies, MSU Committee for Institutional Studies and Reseach, MSU James O. Overby Committee on Kentucky Heritage and Culture, and MSU African American Student Services and Ethnic Programs.

Copyright © 2000 by The University Press of Kentucky
Scholarly publisher for the Commonwealth, serving Bellarmine College, Berea College, Centre College of Kentucky, Eastern Kentucky University, The Filson Club Historical Society, Georgetown College, Kentucky Historical Society, Kentucky State University, Morehead State University, Murray State University, Northern Kentucky University, Transylvania University, University of Kentucky, University of Louisville, and Western Kentucky University.

All rights reserved.

Editorial and Sales Offices: The University Press of Kentucky
663 South Limestone Street, Lexington, Kentucky 40508-4008

04 03 02 01 00 5 4 3 2 1

Cover: *Caribbean Vendor, Bird Vendor,* 1953, oil on canvas, 39 × 24 inches. Hampton University Museum, Hampton, Virginia.
Frontispiece: Ellis Wilson. Photograph © Chester Higgins Jr.

Library of Congress Cataloging-in-Publication Data

The art of Ellis Wilson / Albert Sperath ... [et al.].
 p. cm.
 "Touring itinerary: university art galleries, Murray State University, February 14-March 14, 2000; University of Kentucky Art Museum, Lexington, Kentucky, April 8-June 25, 2000."
 Includes bibliographical references.
 ISBN 0-8131-0980-9 (paper : alk. paper)
 1. Wilson, Ellis, 1899-1977—Exhibitions. 2. Afro-American painting—Exhibitions. I. Sperath, Albert, 1944- II. Wilson, Ellis, 1899-1977.
III. Murray State University. IV. University of Kentucky. Art Museum.

ND237.W7344 A4 2000
759.13—dc21
[B] 99-054111

This book is printed on acid-free paper meeting the requirements of the American National Standard for Permanence of Paper for Printed Library Materials. ∞

Manufactured in the United States of America

Contents

PREFACE

Albert F. Sperath

THIS PROJECT BEGAN four years ago as a result of several events. My first exposure to the work of Ellis Wilson occurred shortly after I became Director of University Art Galleries at Murray State University in 1990. I came across Wilson's painting *End of the Day* in our collection, and I noted to myself that I must eventually find out more about the man who painted such an unusual scene. In 1994 David P. Duckworth contacted me for information about Wilson and the painting we owned for an article he was writing for *International Review of African American Art*. Duckworth reproduced *End of the Day* for his essay, which was published in 1991. Through Duckworth, I learned that Wilson had been born and raised in Mayfield, Kentucky, twenty-five miles from the Murray State campus.

Then two years ago my colleagues Dr. Steve Jones and Eva King came to my office and asked if I had ever heard of Ellis Wilson. I said yes and proceeded to show them our painting, which led to a lengthy discussion about him, his legacy, and how we might celebrate his centennial, which was coming up very soon. We had a second meeting and decided to pull out all the stops and propose to organize a traveling retrospective exhibition, publish a monograph, host a symposium, and contact KET, our PBS affiliate, about producing a television program about Wilson,

all to occur in the year 2000. We also committed to examining Wilson from several perspectives, a rather rare but inclusive type of research. Jones and King would write a short cultural anthropological study, I would curate the show from a studio artist's perspective, and Dr. Margaret Vendryes, of Princeton, would contribute an art history essay on Wilson's work. Our hope was to offer in one document as complete a picture as possible of Ellis Wilson—his determination to become an artist, how he functioned in a segregated environment, how his skill compared with his peers', and what he chose to share with us through his paintings.

We introduced the idea to the Murray State University faculty and administration, and they committed to supporting the project with money and encouragement. Since then the project has been an exhausting and exhilarating experience, and without help from many people and organizations it would not have been possible for us to realize our goals. First I must thank David P. Duckworth, whose initial research on Wilson was invaluable. He developed the beginnings of the catalogue raisonné, shared the information with me, and encouraged me to continue to build it.

Members of the Wilson family have also been very encouraging and supportive. Alice Wilson and Devony Willis have loaned

works in their possession and recounted for me their memories of Wilson and Mayfield.

Murray State University has been invaluable, contributing research funds, time, and encouragement. We offer special thanks to Dr. Kern Alexander, Dr. Joe Cartwight, Dr. Ken Wolf, Dr. Ted Wendt, and Prof. Dick Dougherty. And the many collectors, both public and private, helped immensely. Searching for Wilson's work was like sending out a chain letter, with each new discovery pointing me toward more leads. After this book is published and the retrospective goes on tour I am sure more collectors will be revealed.

EVERYTHING OF INTEREST AND BEAUTY

Margaret R. Vendryes

"I WANT TO PAINT ALL THE TIME—everything of interest and beauty!"[1] This was Ellis Wilson's exasperated plea to the John Simon Guggenheim Memorial Foundation in 1939. At midlife, Wilson knew that he loved painting above all else, and winning the Foundation's fellowship offered the opportunity to paint all the time.

After enjoying over a decade of faddish popularity in the 1920s, black American artists faced diminished sales and exhibition venues. Nonetheless, they continued to create art and push for their due in a depressed American marketplace. Although the United States was in recovery from the decade-old stock market crash, artists of all races faced massive competition for the few collectors and patrons who had survived the economic crisis. Wilson, undaunted by rejection, applied for the Guggenheim fellowship for four consecutive years. He believed his gift for making poetry out of everyday life would blossom if he had the chance to concentrate all his energy on painting.

In the summer of 1944, the Guggenheim Foundation awarded Wilson the first of two years of support to "create paintings which will be a credit to [his] race and [his] time."[2] By this time, he had been painting for over half of his life. His determination reflected the depth of his need to make art. Wilson was born and raised by industrious

working-class parents in Mayfield, Kentucky, a small town with no claim to producing artists. His parents whole-heartedly supported Ellis's education, but that he might mature into a professional artist hardly occurred to them. Later, when asked why he became a painter, Wilson modestly credited his father, Frank Wilson, for his artistic inheritance.[3] Two paintings by the senior Wilson, a landscape and a religious scene, were already dark with age by the time they became familiar parts of Ellis's childhood. A barber by trade, Frank Wilson did not pursue his art beyond these two, prominently displayed canvases. In tribute to his father, Ellis was listed in the 1933 Harmon foundation catalog directory as the "son of an artist."

Wilson left Mayfield for Chicago in the summer of 1918/19 to attend classes in applied art at the School of the Art Institute of Chicago, one of few in the country to enroll black students.[4] Within days of his arrival, race riots marred the Windy City's urban landscape, making travel around the city dangerous. Yet Wilson remained undiscouraged by the destruction and fear Chicago's race conflicts left in their wake. He took refuge in his art and quickly became a die-hard city dweller.

Wilson took a practical approach to art education by studying commercial art and working for wages, as did 65 percent of the

male students enrolled at the school during that time.[5] Although his themes were carefully chosen, color was Wilson's primary expressive tool throughout his career. Materialistic urban life carried no aesthetic punch, but Wilson found great pleasure in his carefully orchestrated still life paintings, such as the one reproduced in the 1933 Harmon Foundation exhibition catalog. He remarked that, in that picture, the way the colors vied for attention sent him "up the wall."[6] (Figure 1)

Wilson's early pictures were neutral subjects, usually still life or landscape, which were easy to come by and forgiving models for a beginner. Neutral subject matter preserved an artist's autonomy by obscuring race, religion, age, gender, and even nationality. Several of Wilson's contemporaries, who aspired to exhibit and sell their work without drawing undue attention to race—Albert Smith, James Porter, and Lois M. Jones among them—also understood these advantages.

But the gentility of Wilson's still life compositions exposed class status or, at least, class aspirations. Fruit and vegetables, symbols of prosperity and fecundity, tastefully arranged with polished metal, delicate glass, and reflective wood surfaces marked the inherent joy that Wilson took in owning and illustrating beautiful things. The few surviving pictures from Wilson's early years in Manhattan reflect the pleasure he took in recording small corners of life over which he exercised some control.

Wilson earned his professional status by completing four years of art education. He became a draftsman and designer trained to focus on composition, detail, and finish. Even though he worked part time as a commercial artist in Chicago, Wilson held menial service jobs to make ends meet. He

and fellow struggling artist Richmond Barthé dreamed of traveling to Paris and New York where they would bond with their artistic muses and support themselves making art. Both loners by temperament, each realized that dream over time as he entered the ranks of the elite group that W.E.B. Du Bois referred to as the "Talented Tenth."[7]

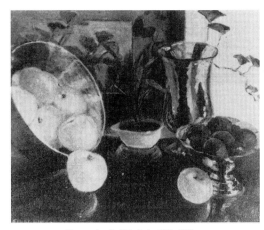

Figure 1. Still Life *by Ellis Wilson*

As the image of a modern New Negro took form with the publication of Alain Locke's seminal anthology of black American art and letters, *The New Negro* (1925), visual artists were urged to create specific and positive representations of African America. An important component of the New Negro program was the creation of a distinct public image potent enough to unseat racist stereotypes. Wilson was apparently moved by Locke's agenda because less than a year after hearing Locke speak at Chicago's groundbreaking 1927 art exhibition, "The Negro in Art Week," Wilson relocated to Harlem, African America's renowned cultural capital. That year was also marked by the Harmon Foundation's first expansive exhibition, "Productions of American Negro Artists." The Harmon Foundation was established in 1922 as a philanthropic outlet for its founder, real estate baron William E. Harmon. Although the good works of the foundation were not lim-

ited to helping African Americans, it is primarily remembered as the forerunner in the promotion of black American visual art. The foundation's jury included Wilson's figure study *An Artist* in the 1930 exhibition, and the still life mentioned earlier appeared in the final exhibition of 1933. Unfortunately, the whereabouts of both paintings remains unknown.

Wilson moved downtown to the outskirts of Greenwich Village after three years of isolation in Harlem. He found the neighborhood of inexpensive, cold-water walkup apartments liberating. Wilson explained that "the artists were in the Village" and that he could no longer endure the detachment that living in Harlem represented.[8] Wilson furthered his remove from race politics by opting not to enter the historic NAACP exhibition opposing lynching in 1935. The subject was "too gruesome" for his art.[9]

Wilson recognized that appearing involved in politics was wise but later confessed that politics had always "bored" him.[10] He painted African Americans because their lives were inspirational not because they were popular subject matter. In Wilson's opinion, "Negro" art, and later "black" art, identified the artist and not the art. He remained aloof from radicals such as Romare Bearden and Charles Alston, whose aggressive tactics were admittedly instrumental in gaining increased exposure for black American artists. By disassociating himself, Wilson was left to make his way in a white-dominated, Social Realist art scene that gave short shrift to people of color. Wilson made an effort to work within that environment by painting pictures of tenements, children at play, and women at work while settling for nothing less than perfection.

Wilson's concern with painterly gesture, affinity with nature, and ability to strike a coherent balance between the two were lifelong strengths. He was able to concentrate on painting to enhance his popularity and marketability in New York. He offered his work to black American civic journals such as the *Crisis* and the *Tattler*, because they published work by emerging artists. Aaron Douglas and Allen Freelon painted urgent, race-positive narratives that frequently graced the pages of the *Crisis*, where a marriage between art and propaganda was sanctioned.[11] Douglas's sharp-edged, neo-Africanist style, in particular, would have a lasting effect on Wilson's art.

Little was made of Wilson's portrait-quality head of a young man chosen for the May 1929 cover *of* the *Crisis*.[12] (Figure 2) Wilson was shy and reserved, and his art appeared quiet and conventional. He clung with pride to the academic precepts acquired over four determined years of art classes, which had taught him not only to work from life but to reflect its best side in the process. But Harlem's competitive, up-and-coming black American artists vied for public attention using art that flirted with geometric abstraction and reflected the rhythm of city life.

No black American artist supported himself solely by the sale of his art in the 1930s. High levels of energy and optimism were needed to sustain creative instincts. Wilson was steadily employed as a handyman and enjoyed job security, which was especially scarce for African Americans. Palmer Hayden, a friend and fellow down-

Figure 2. *Wilson's work on the cover of Crisis, March 1929.*

town painter, created *The Janitor Who Paints* as a pointed tribute to black American artists' persistence and devotion to their profession.

Wilson's employer, Horace S. Gumble, was sympathetic to the artist's creative ambition. He paid for Wilson's weekend art classes to further his developing skills. Several black American artists, determined to make a mark on the art scene, took classes to learn from recognized professionals, use studio space, and network with other artists. William H. and Malvin Gray Johnson took courses at the National Academy of Design on Fifth Avenue. Others took advantage of community schools supported by Roosevelt's New Deal programs, such as Augusta Savage's Harlem Community Art Center, which fostered the development of Jacob Lawrence among other notable artists. Wilson was also involved with Savage's studio while he lived in Harlem.

Beginning in 1931, Wilson devoted over three years of weekends to studying portrait and life painting with Xavier J. Barile (1891-1981) in addition to taking applied design courses at Mechanics Institute. Barile ran an art school out of his studio only four blocks down from Wilson's building on West 18th Street. Barile was a longtime student and friend of John Sloan, Robert Henri's devoted student. Henri advocated using art as a mirror on all walks of city life, and his followers became known as the Ash Can School. It was Henri who said, "what is necessary for art in America is first an appreciation of the great native ideas . . . and then the achievement of masterly freedom in expressing them."[13] These men were also skilled printmakers who published extensively in national journals. Through exposure to this tradition, Barile's monotypes (a hand-executed printing technique prized for

its unique textural qualities) remain some of his best work.[14] Barile's humanist philosophy and the linear quality of his pictures partially liberated Wilson's tight hold on academic painting, something he tried to transcend throughout his entire career. He regretted never having "gotten rid of being an academician," even though his most successful paintings were dependent on that skill.

Although Wilson enjoyed a rich social environment where supportive colleagues such as Beauford and Joseph Delaney, Robert Poius, Palmer Hayden, and Barthé were his neighbors, he remained frustrated by the limits of day to day life. Unlike Beauford Delaney, his lifelong friend, Wilson was far from bohemian. He had modest aspirations for financial and professional success and kept to himself more often than not. Exhibiting was a burden because framing, crating, and shipping—the artist's responsibility—inevitably taxed his subsistence income. Wilson knew that only white philanthropy could help him realize his dream to devote all of his time and energy to painting.

Wilson's career took a positive turn when Farroll Brothers Brokerage laid him off in 1935. He took this opportunity to become a self-proclaimed, unemployed artist. Armed with Harmon Foundation catalogs, he applied for work with the Federal Arts Project of the Works Progress Administration, a New Deal organization employing artists to embellish public spaces. Wilson joined the FAP ranks within the year and was retained for six more. The United States government paid approximately thirty-five million dollars for over a hundred thousand works of art during the New Deal era.[16] Even though gifted painters such as Jackson Pollock and Mark Rothko, who later became canonical, were employed by the project, thousands of paintings were "sold by the pound as junk"

when the Works Progress Administration disbanded in 1943.[17] Fortunately, Wilson's pictures were not among them. Wilson was assigned to a mapping division creating geographical dioramas, work that undoubtedly inspired his paintings' characteristically detailed and textured surfaces. Wet sand, blades of grass, leaves on trees, and even the polished dance floor sailors and their sultry partners slide across in *Shore Leave*, all have individual character.

Wilson's pictures are sober and quite serious in purpose, often abbreviated but never caricatured. He avoided the negative critiques his friend Palmer Hayden endured when he used vaudeville, black-face conventions to rework negative stereotypes and challenge African Americans to see the humor in their lives.

Painting on his own in the evenings and on weekends, Wilson became determined to compose enough good paintings to compete for private funding. Several of his colleagues, Archibald J. Motley Jr. and Richmond Barthé among them, had enjoyed years of support from the Rosenwald and Guggenheim foundations. These artists' careers accelerated once they were able to concentrate on making art. Technical skill seemed to be the key to their success with the foundations because they did not share similar styles or thematic choices. Motley profited from picturing Chicago's black belt with unabashed enthusiasm and a well-trained painter's eye, while Barthé modeled professionally staged dramas with a deft, and decidedly neoclassical, sculptor's touch. Like Wilson, both artists had graduated from the School of the Art Institute of Chicago.

For those looking in, Africa was seen as the common denominator of all black people, despite the overt and dominant assimilation practices of most African Americans during the first half of this century. The crux of a renaissance is the reclamation of a lost heritage. African Americans looked to Africa for cultural reawakening; therefore, in addition to their longing to preserve rural African America in art, black American artists' fellowship applications inevitably included reference to Africa. Motley waxed nostalgic about his wish to visit West Africa to record its people and their customs, and later Barthé followed his example. Both won fellowships; neither visited Africa.[18] On his Guggenheim Foundation application, Wilson also thought it necessary to mention Africa as a possible location to gather material, but his most consistent references were to the deep South in general, and to the sea islands in particular.

After winning the Guggenheim fellowship in 1944, Wilson's paintings, already inherently organic, took on new life. Wilson's newfound independence appeared directly on the surface of his pictures. His brush raced across Masonite much as his celebrated contemporary Willem deKooning's did across canvas but with a restraint and representational containment the Abstract Expressionist avoided. Wilson had an affinity with American artists such as Marsden Hartley and Arthur Dove. Hartley created rough-hewn figures of autobiographical significance; Dove's spare abstractions tapped the psychological importance of color and shape. Wilson combined the two by balancing carefully proportioned figures within an organic geometry of colors and shapes to document personal visual experiences.

In a simple and singular language, the shy Ellis Wilson spoke out through his art. He admired contemporaries Jacob Lawrence and Aaron Douglas, both of whom made extensive use of African art and abbreviated their figures through silhouetting.[19] Wilson,

inspired by what these men had accomplished, raised his own voice in pictures that developed and expanded on Lawrence and Douglas. His preference for crayon colors enhances the familiarity and nostalgia one feels before Wilson's pictures. His intelligently arranged palette places complementary and contrasting colors in perfect harmony. Pure red vibrates against green in *South Carolina Mules* (plate 9) and *Woman in a Red Dress* (plate 3). These color vibrations also help us to sense the heat of a sun-soaked afternoon and to imagine the cool blades of thick grass under-foot. Wilson made art for the sheer joy of recreating, in color applied with forever dancing brushstrokes, what he witnessed in other people's lives. He was an insatiable recorder of the beauty that most take for granted.

Wilson's treatment of South Carolina's sea island African Americans was in stark contrast to that of well-known photographer Doris Ulmann. In the early 1930s, Ulmann's pictures of the Gullah Islands peoples made the everyday appear mysterious and majestic.[20] In 1939, Mason Crum, a one-time resident of the sea islands, remembered how the Gullah people "have lived at peace with their world, and while not many have laid up treasure upon this earth, they have as a race maintained an inner peace and composure which is without price."[21] Ulmann's low-light, soft-focus exposures are solemn documents of a life many believed faced extinction. (Figure 3) However, Wilson avoided the uneasiness one senses in Ulmann's subjects not only because he, as an African American, was more at home among these people but because his method of making quick sketches was less intrusive than the manipulation of apparatus required to take professional photographs.

Wilson required and respected privacy.

He worked alone and had very little to say about his painting methods. He gathered material from life but did not paint on site. His sketches are impressions brought back to life in paint in his own time and place. This method accounts for the intimacy we experience in each picture. Like the lone, broad-backed fisherman effortlessly carrying a catch half his size, Wilson's vignettes are magically animated with layers of living colors that shimmer. (Plate 10)

Wilson was unable to completely exorcize his deep Kentucky roots, even after years of conscientious practice subdued his once telltale country accent. As the naturalistic figure became unpopular, Wilson's staple, narrative figure compositions exposed his unwavering dependence on the natural world. He framed self-reliant black people as picturesque actors in narratives of their own making. People, nourished by the earth and surrounded by the sea, fueled the artist's imagination. His studio-rendered pictures of country folk contrasted greatly to the more popular works by city-raised contemporaries such as Jacob Lawrence, whose spirited and thoroughly urban angularity spoke to an age where the working-class poor appeared like cogs in one huge commercial machine. Wilson was more a voyeur of peoples' lives than a critic. By the late 1940s, painting, the most tradition-bound of all two-dimensional media, had developed into a medium for individualistic

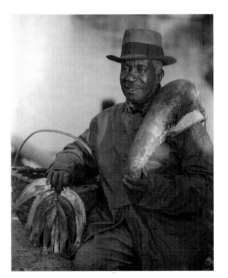

Figure 3. *Doris Ulmann's "A Sea Island Fisherman," 1929. Special Collections and University Archives, University of Oregon Library System.*

and abstract expression. Wilson's art remained pictorial and steadfastly accessible, making complete and articulate statements within small rectangular frames.

Wilson's intimate, window-sized views on worlds he visited but never fully participated in appear like romantic Arcadias from times past. The small scale of Wilson's pictures can be attributed, in part, to the cost of materials and limited studio space, but the portable size also served his message well. Up close, we can observe detail without sacrificing the whole. Melancholy is rarely evident in Wilson's paintings, even though smiles rarely appear on his figures. Even when faces are obstructed, such as in *Flower Vendor* (cover), the upbeat colors, lines, and textures result in a visually playful tune. Even today, Wilson's art upstages the artist, who gladly remains in the shadows.

The windfall 1952 prize from Miami's Terry Art Institute made Wilson's first visit to Haiti possible. Although Africa was the site for reclamation of a collective past and enrichment of African America's future, Haiti, the first black republic in the New World, became the intermediary site between African America and Africa. Beginning with William E. Scott, a significant number of black American artists and writers traveled to Haiti to experience what it meant to be among the majority and ruling race, and to revitalize their art.[22] Scott's approach to making art was unchanged by his experience in Haiti. In contrast, Wilson was taken with the native art based on unwavering folk tradition. Haitian painters were straightforward, lyrical, and detailed without being fussy. Their direct use of color and daring breaks with perspective had a profound influence on Wilson's art.

Pictures of community take over as delicately silhouetted groups begin to dominate his once-favored single-figure compositions. Overlapping figures, such as those depicted in *Shore Leave*, reappear after Wilson discovers lively silhouettes of Africa thriving in Haiti. The fragility of African traditions, threatened by modernization and capitalism encroaching on the island's culture, is reflected in the stained-glass quality of Wilson's paintings. Without use of traditional chiaroscuro, well-placed color added perspective, solidity, and stability to his compositions. In the rural South series of 1944-45, figures are distinct and separate even when grouped together. Something new surfaced in Haiti as Wilson observed communal life in its chaos and its efficiency. In his Haitian paintings, figures overlap with each other and with their surroundings. One can hear the ruckus of street life in *Camion #1* and the well-choreographed dance of figures in *Colonade Promenade*. (Plate 24) We read a narrative of lives moving in perfect unison from left to right held together by a proud shared heritage. In commerce or in communion, Wilson's figures are regal in their uniformed darkness. Visual belonging mocks rampant intraracial conflicts still disquietingly real in the African Diaspora.

Wilson choreographed flat, clearly demarcated forms, descriptive color, and a variety of perspectives within one picture plane to narrate folktales rather than to mirror reality. In his Haitian paintings, overlapping figures create a human chain that highlights a collaboration of effort most aptly described as community. As a black man, Wilson felt a personal connection to Haitians, but he was still an outsider, a visitor to their land. The distance was heightened further once he was back in his New York studio, but the rhythm and texture of the people he observed remained embedded in his mind's eye. Decorative details abound in pictures where design

acts as the chorus to a symphony of color. The dance of green leaves, the glow of a flame beneath stained glass, the bunching of chairs, or flowers, or people all reveal a unique, personal rhythm delicate as the notes of a flute compared with the aggressive drum beat of artists such as Eldzier Cortor and Romare Bearden.[23]

Ellis Wilson was a solitary artist who believed that art should provide pleasure above all else. He separated his pictures from history, politics, revolution, celebrity, sensationalism, and the vagaries of urban existence. The Beat Generation, which encouraged experimentation, found Wilson past midlife—at the height of his creative power. The Beats were a small but influential circle that fostered interracial contact and alliances between the arts. Improvisational jazz and poetry inspired art of this period. Wilson was not immune to this aesthetic revolution. Pointing out the fantastic inherent in the everyday, he tuned natural color to a higher key or neutralized color to highlight detailed fabrics. Wilson described life's nuances on the surface of his paintings. He captured the ease of loosely clad black limbs, the deep tremor of black voices, the cadence of strong women and men, and the sensuality of able-bodied activity. We are fortunate that his art survives as a testament to the value of a life lived for beauty—and everything of interest.

NOTES

1. From Wilson's application for the 1940 John Simon Guggenheim Memorial Foundation awards, dated Sept. 26, 1939.

2. Ibid.

3. Ellis Wilson to Camille Billops, Feb. 25, 1975. Interview in Billops-Hatch Collection, New York.

4. Lottie Moss of Niles, Michigan, is documented as the first black American student to attend the Art Institute School shortly before the turn of the century. Bearden and Henderson, 338.

5. Roger Gilmore, ed., *Over a Century: A History of the School of the Art Institute of Chicago, 1866-1981* (Chicago: The School of the Art Institute of Chicago, 1982), 81.

6. Wilson to Billops.

7. In the opinion of the black American literate, the talented, educated, literate, presumably middle-class, and overwhelmingly male one-tenth of one percent of African America was responsible for restructuring the race's social and civic image. A discussion of the Talented Tenth in the context of the Harlem Renaissance can be found in David Levering Lewis, *When Harlem Was in Vogue* (New York: Oxford University Press, 1979).

8. Wilson to Billops.

9. Ten of the thirty-eight artists exhibiting in "An Art Commentary on Lynching" were black American men. For more about this groundbreaking attempt at art as a propagandistic tool, see my essay, "Hanging on Their Walls: An Art Comment on Lynching, The Forgotten 1935 Exhibition," in Judith Jackson Fossett and Jeffrey A. Tucker, eds., *Race Consciousness: African American Studies for the New Century* (New York: New York University Press, 1997).

10. Wilson to Billops.

11. For more on this topic see Abby A. Johnson and Ronald M. Johnson, *Propaganda and Aesthetics: The Literary Politics of African-American Magazines in the Twentieth Century* (Amherst: University of Massachusetts Press, 1979).

12. Bearden and Henderson, 339.

13. Robert Henri (1909) quoted in Milton Brown, *American Art* (New York: Harry N. Abrams, 1979), 352.

14. Clipping from the *Journal of the Archives of American Art* (Oct. 1987) in picture files of the New York Public Library.

15. Wilson to Billops.

16. For more information on this topic see Francis V. O'Connor, *Art for the Millions: Essays for the 1930s by Artists and Administrators on the WPA Federal Art Project* (Boston: New York Graphic Society, 1975), 250.

17. Edward Laning, "Memoirs of a WPA Painter," *American Heritage* 21, no. 6 (Oct. 1970): 42.

18. According to James Porter, Elton Fax was the first black American visual artist to actually visit Africa in the 1960s. James Porter, "Afro-American Art," in The California Arts Commission, *The Negro in American Art*, ex. cat. (Los Angeles: Dickson Art Center, 1966).

19. Thomas Riggs, ed., *St. James Guide to Black Artists* (Detroit: St. James Press, 1997).

20. Several of Ulmann's photographs of the Gullah people were published in Doris Ulmann and Julia Peterkin, *Roll Jordan Roll* (New York: Robert O. Ballou, 1933).

21. Mason Crum, *Gullah: Negro Life in the Carolina Sea Islands* (Durham: Duke University Press, 1940), 89.

22. William E. Scott (1884-1964) created over a hundred finished paintings of Haiti's native inhabitants in 1931 under a Rosenwald Foundation grant.

23. Cortor also visited South Carolina's sea islands in 1944-45 under a Rosenwald fellowship. His visit inspired several surrealist paintings with overt political commentary.

ELLIS WILSON, A Native Son

Steven H. Jones and Eva F. King

ELLIS WILSON'S early experiences in the small western Kentucky town of Mayfield were to have lasting influence on his evolution as an artist. The community in which he spent his childhood shaped his early personality and value system. Throughout his career he would paint scenes of the everyday life of black people, and his portrayals would reflect black cultural themes of family, work, and religion—institutions that had been so important to his family, and consequently to Wilson, in Mayfield. Wilson's artistic interpretations were filtered through the lens of his early experiences in his hometown.

Although no formal history on the topic of race relations in Mayfield exists, valuable oral history has been collected.[1] At the beginning of the twentieth century, shortly after Ellis Wilson was born, Mayfield, like most places in the southern United States, was racially segregated, and blacks had restricted access—in some cases no access at all—to public institutions. The forced isolation of the black communities in the early 1900s made possible the development of distinct

Figure 4. *Mrs. Minnie's church, Mayfield, Kentucky.*

institutions such as the black church and the black family, which differed from their mainstream or white counterparts.[2]

In the early 1900s, the African American community in Mayfield was smaller and more spatially confined than the white community. The black neighborhoods had specific names—Out-Cross-the-Ditch, Boxtown, Pee Wee Ridge, Out-in-the-Field, and the Bottom, which was the largest section. These areas had a rural flavor. Some people owned horses and wagons, and many raised pigs and chickens. Some Out-Cross-the-Ditch residents had barns located on their property, even though they lived within the city limits. Ellis Wilson lived in the Bottom community with his extended family; in a 1975 interview he described his family as "country," referring more to their way of life than to their physical locality.[3] This rural lifestyle was more common in the black sections of Mayfield than in the white neighborhoods in the early 1900s. This background would later enable Wilson to understand and identify with rural blacks in the southern United States and in Haiti and to produce colorful bodies of work depicting rural society.

The Bottom neighborhood included several churches, one of which was the Second Christian Church (figure 4), which had been founded by Ellis Wilson's mother, Min-

nie. Friends and family members remember the Wilson children spending a good deal of their time at the church, which was located a block from the Wilson home (fig. 4) on the same street. Ellis Wilson's nephew James Wilson said, "Uncle Ellis called the church 'Mrs. Minnie's Church,'" a familiar term of reference for the church. Next to the church was a large grocery store and a family restaurant called Streets. Other black-owned businesses in the Bottom were a barbershop owned by Ellis Wilson's grandfather and later his father, Frank Wilson; a funeral home; and a movie theater.[4] A black physician, Dr. Taylor, resided in the Bottom and, according to Ellis Wilson, provided a place for young people to go on Sundays to dance and play piano.[5]

The system of legalized segregation barred African Americans from access to goods and services, so they developed their own resources such as the businesses mentioned above. This situation made it possible for business owners such as Frank Wilson to generate income and leisure time that afforded them opportunities not available to black common laborers. For example, Frank Wilson used revenues from his barbershop not only to support a wife and children, but he also took painting lessons from an itinerant teacher of art and produced some paintings that family members remember to this day. Ellis's memories of his father studying with the white teacher inspired him to become an artist himself. In an interview in 1975, he said "I guess I got what little talent I have from him."[6]

In the early 1900s, all blacks who attended school in Mayfield, including Ellis Wilson, went to the Colored Graded School located in the Bottom.[7] The school, by many measures the most important community institution in the Bottom, had an all-black staff and was relatively independent from the city school system. This nurturing environment allowed blacks to develop significant measures of dignity and confidence in their skills. Wilson exhibited these qualities in his determination to acquire an education and in his belief that he could become an artist.

Most black citizens in Mayfield at the time were considered impoverished by whites using

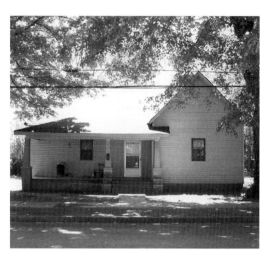

Figure 5. *The Wilson home, Mayfield, Kentucky.*

the standards of the day; however, the black community was viewed by blacks as economically stable and socially cohesive. Blacks and whites encountered each other in the economic sphere. Wilson's family had a strong work ethic, which was the social norm in the community at that time. His mother and sister worked as maids for a white family. Ellis Wilson mowed lawns and worked in tobacco, and his male siblings likely had similar jobs in and around the community. At one time Ellis Wilson worked as a janitor of Day's Ready-to-Wear Dress Shop. (His portraits drawn in cleaning wax on the store window attracted the attention of passersby and delighted the white store owner, who encouraged the weekly drawings.) Wilson developed a respect for manual labor and self-sufficiency.

When Ellis Wilson was born in 1899, the structure and functional patterns of the black family in America differed from those

seen today. In the latter part of the twentieth century, only four out of ten black nuclear families have both parents living in the home; in the early 1900s, eight out of ten black families were headed by two parents. The black family at the end of the nineteenth century was strong, resilient, and adaptive.[8] The Wilson family, which consisted of mother and father—each of whom worked and had interests outside the home—six sons, and one daughter, was no exception.

Since the seventeenth century when blacks first entered American society, the black family has been strengthened by an extended structure (a group of related nuclear families and other relatives). Wilson family members were able to call on relatives and close friends for help, particularly in times of need and when relocating for employment or education purposes. Frank Wilson, for example, sent money to his son when he went to Chicago to study at the Art Institute in 1918/19. Later, after moving to New York to further his career, Ellis Wilson, who never married or had children of his own, helped and encouraged a favorite niece, Alice Wilson, when she traveled from Mayfield to attend Hampton Institute in Virginia in the late 1950s. Wilson also helped to support his nephew James, lending encouragement and sending money over the years after Johnny, James's father, died. Ellis frequently traveled back to Mayfield, reinforcing his ties with members of his extended family. He enjoyed drawing family members. On one of his visits, he sketched his young nieces Alice and Fannie Etta, and young nephew Frank in charcoal and pastels. In this way, he was literally imbibing from his original wellspring of black culture.[9]

The family portraits that Wilson produced were given to family members, and none was ever displayed in his exhibits; how-

ever, the theme of family can be observed in many of his widely exhibited paintings. *Two Mothers* (plate 12), c. 1946, likely painted on a southern plantation during Wilson's Guggenheim Fellowship travels, depicts two women standing side by side, almost symmetrically, with children on their hips, a small child peering from behind one of the mothers. Many of the paintings inspired by his visits to Charleston and the Gullah region of the South Carolina Sea Islands are of mothers and children, sisters, and brothers. *Edisto Family*, exhibited in 1948, portrays two women and a small boy holding a fish. *Sisters*, c. 1947, features four black females wearing similar dresses. Family again is the subject of *Field Workers*, a Haitian scene painted in the 1950s: a mother, father, and four children—one a baby being carried on an older child's hip—are going off to work in the fields. Wilson's strong and lasting interest in painting family compositions may be attributed to the importance of familial relationships to the artist.

At a very early age Ellis Wilson wanted to be an artist; however, historical and cultural movements of the first half of the twentieth century significantly restricted his educational and professional opportunities. He, like most African Americans of his generation, was not fully aware of his part in the Great Migration of blacks from the South to the North.[10] "Hundreds of thousands of African Americans migrated from the rural, mostly agricultural South to the urban industrialized North from 1913 to 1946," writes Sharon Patton in *African American Art*. Economic booms after both world wars and "the effects of overt racism brought on by Jim Crow laws (segregation sanctioned by law in the South in the 1890s)" prompted blacks to move north.[11] In 1919, blacks were prohibited from attending white colleges in

15

Kentucky, and the all-black Kentucky State College in Frankfort offered degrees only in agriculture and teaching. Ellis Wilson attended Kentucky State College for two years before convincing his father to allow him to go to Chicago. Wilson simply wanted to study art, but he had to leave his home state to do so.

Like sculptor Richmond Barthé from Mississippi and printmaker Dox Thrash of Georgia, Wilson moved to Chicago seeking formal instruction in his chosen field. In all likelihood, Frank Wilson's own artistic interests induced him to encourage his son's decision to move north to attend the Art Institute of Chicago and to support him financially while he was a student there. Wilson arrived in the city in 1918/19, but his plans to enter the Art Institute were postponed for a year because of race riots that occurred in 1919.[12] He worked in a YMCA cafeteria to support himself while he attended classes. In 1923, he graduated from the Art Institute and then stayed in Chicago for five more years working as a commercial artist.

In 1928, Wilson moved to New York, where he resided and continued to paint until his death in 1977. Unable to support himself solely by his art, he worked at a brokerage firm from 1929 to 1934, first doing maintenance and messenger work and later recording grain transactions. The Depression and the New Negro Art Movement of the Harlem Renaissance were important influences in his life and career. The Depression, which was particularly harsh for African Americans, provided a silver lining for black artists in its Works Progress Administration's Federal Art Project, inaugurated by the government to allow artists to earn small salaries for many aspects of artistic production. From 1935 to 1940, Wilson participated in the program, as did many black artists, among them Joseph and Beauford Delaney, Jacob Lawrence, Norman Lewis, and Hughie Lee Smith.

The New Negro Art Movement,[13] which began in the 1920s and extended into the 1930s, afforded opportunities for black American artists to exhibit their work and be recognized by a larger audience than they had had access to in the past, especially in the world of professional art dominated by whites. Wilson's work was featured in many exhibitions associated with this movement, among them the Chicago Art League's week-long festival the "Negro in Art Week" in 1927 and the Harmon Foundation exhibits of the 1930s. Mary Beattie Brady, director of the Harmon Foundation, encouraged Wilson's artistic efforts and introduced him to Alonzo Aden, director of the Barnett-Aden Gallery in Washington, which hosted an exhibit of Wilson's work in 1945.

During the New Negro Art Movement, a number of critics attempted to define a black art aesthetic. Alain Locke, African American art critic, well known cultural nationalist,[14] and prominent figure in the New Negro Movement, wrote forewords to the Harmon Foundation Show of 1933 and the New Names in American Art Show in 1944, both of which featured works by Wilson. In an article in his 1925 book *The New Negro*, Locke argued that African American artists could acquire valuable insight into their cultural roots by a return to "the ancestral arts" that were embedded in traditional African culture. Locke, who knew Wilson personally,[15] strove to influence the development of black artists by encouraging them to deepen their own awareness of their indigenous cultural heritage.[16] Some black artists, such as painter Aaron Douglas, were motivated to draw on the history of African

Americans and explicitly infuse their works with African scenes and symbols. Others, like Wilson, made few and subtle references to their African heritage.

Artist and critic James A. Porter argued that black artists should not be concerned with racial philosophy and should simply express their individual perceptions, values, and visions based on their own cultural experiences. "Those of Porter's view felt that an artist should choose freely what and how to produce, and that the study of African art would only lead to superficial copying and interpretation of the primitive, similar to that of white artists."[17]

Ellis Wilson's work represented elements of both Locke's and Porter's philosophies.[18] Following Porter's advice, Wilson drew from those aspects and scenes of black culture that he experienced firsthand. From the tobacco fields of his native Graves County, Kentucky, to the streets of Harlem, to the Gullah Islands off the coast of South Carolina, and to the all-black republic of Haiti, Wilson examined the scope and depth of black culture. The Gullah and Haitian societies reflected retentions of the West African cultural heritage that were and are present in black culture. The Gullah people "who walked erectly and, like Africans, balanced baskets on their heads" intrigued Wilson,[19] and his paintings of this unique group of African Americans display African influenced practices. Wilson's *Janvallou (2)* (plate 36), in which native Haitian dancers are celebrating voodoo, an indigenous African ritual, is a specific example of the ancestral arts.

Wilson's tendency to celebrate the positive aspects of the black experience in his paintings rather than to focus on themes of racial oppression and protest was a reflection of his personality. Described by family members and friends as "easy going," "soft spoken," and very polite, Wilson was nonconfrontational, though a close friend who knew him in Mayfield and in New York said that Wilson was upset by some of the ways blacks were treated in the United States; his quiet manner prevented him from expressing these views in some overt manner. Wilson's stance in part reflected his desire to acknowledge and continue to receive support from white benefactors such as Mary Beattie Brady, who facilitated the showing of Wilson's paintings in Harmon Foundation exhibits, and art critics Justus and Senta Bier, who applauded Wilson's achievements with positive articles and reviews of his shows.

The state of race relations in Mayfield during Wilson's lifetime is difficult to characterize because it depends to some extent on generational perspectives. In an interview in 1975, two years before he died, Wilson was asked about racism in Kentucky. He said, "It existed. I think it was less in a smaller town." He indicated that he felt lucky to have grown up in a community where everyone knew one another; he further suggested that he felt that blacks in Mayfield had had it good compared to their fellows who lived elsewhere in the region.[20] Based on interview data, these views were typical of blacks of Ellis Wilson's generation. But in an interview a year earlier, Wilson had recalled that in Mayfield before World War I it was the custom for black people to step off the sidewalk when white people approached from the opposite direction.[21]

In 1944, on the strength of his paintings of black workers in a New Jersey defense plant, Wilson was granted a Guggenheim fellowship, which was renewed in 1945, allowing him to devote all of his time to traveling and painting. His travels took him back to his roots in Graves County, Ken-

tucky, through southern plantations in Georgia and South Carolina, to the Sea Islands of South Carolina, and later, in the 1950s, to the all-black republic of Haiti.

The Wilson family's work ethic was a critical element in Ellis Wilson's success, especially under societal conditions that routinely demeaned, discouraged, and denied the validity of black initiative and talent. As he struck out on his own to learn his chosen craft, the habits of hard work that he had developed early on no doubt sustained him. And his respect for the entrepreneurial efforts of his grandfather and father and the manual labor of his mother and siblings—and himself—undoubtedly led him to an appreciation of the work done by people of African descent. He was inspired to paint black people engaged in such endeavors in a variety of cultural settings. His participation in the WPA's Federal Art Project allowed him to earn a modest income while working as an artist, and his 1944 and 1945 Guggenheim awards afforded him opportunity to travel and paint full time; but for most of his life as an artist, Wilson continued to work various jobs to support himself. His images of blacks involved in their daily work activities are a result of his understanding of and respect for the institution of work itself. *Watermelon Vendors* and *Sewing Girls* were among his paintings completed in Harlem in the 1930s.[22] Of his 1940s series of paintings of black workers in an airplane factory in New Jersey, Wilson was quoted as saying, "That was the first time I had ever seen my people working in industry, so I painted them."[23] After being awarded the Guggenheim, Wilson continued to provide audiences with images of black workers. He painted lumber, turpentine, and tobacco workers in the South; in his native Graves County, Kentucky, he made watercolors of workers in the

local clay mines. He painted black people at the markets in Charleston, South Carolina, as they came and went carrying their baskets of goods. *Flower Vendor* is a portrayal of a seated woman in a large yellow hat with a colorful array of flowers to sell. Wilson's series of paintings of the Gullah people from the South Carolina Sea Islands, such as *Going Shrimping*, *Fishermen's Wives* (plate 4), and *End of the Day* (plate 10), depict the people's daily fishing activities. Wilson once said of the people from the Sea Islands, "I was attracted by their simple poise and dignity."[24]

Wilson's approach to painting began to change with his South Carolina Sea Island paintings. In his efforts to express his admiration for this culturally unique group of African Americans and to translate their way of life, Wilson began elongating and simplifying the figures while diminishing the details of their environments. *End of the Day* (plate 10) presents a man, and *Fisherwoman* portrays a woman, each carrying a fish. In Wilson's colorful style, the figures dominate the paintings, with the sea and beach serving as a backdrop to the strong characters. Unlike his previous documentary-style depictions of black defense workers and farm laborers, Wilson's paintings of the people of the coastal communities went beyond mere representation in his vivid use of color and strong sense of rhythm. Justus Bier, art historian and art critic for the *Louisville Courier-Journal*, considered Wilson's South Carolina paintings "poetical transcripts, eminently successful in transmitting the strong emotion attached to the subjects he chose to paint."[25] With less attention to realism and more emphasis on color, design, and expression, Wilson moved toward a more contemporary style of painting, which continued when he went to Haiti in 1952.

In Haiti, Wilson spent days observing and sketching the busy Haitian peasants at markets, bus stops, the beach, and in their villages. As he observed people coming and going, he realized that he didn't see their facial features. They were like black silhouettes; he started painting the figures flat and moved toward a more stylized form.[26] He began presenting the elongated figures without detailed description, faces without eyes or mouths, clothing without folds. Tall, silhouetted figures and brilliant colors became characteristic of Wilson's paintings, and in most of them, the figures continued to be involved in daily work activities. In reviewing Wilson's 1954 "Impressions of Haiti" exhibit at the Contemporary Art Gallery in New York, Senta Bier described scenes of people involved in "simple household tasks, vendors, women carrying fruit to the market." She commented: "Through his simplifying style these scenes of Haiti are transformed somehow into scenes of the life and being of simple people everywhere and at any time."[27] The silhouetted figures in *Chair Vendors (Haiti)* (plate 30), *To Market* (plate 35), and *Marchande* (plate 21) form colorful patterns with their various loads of wares for sale. An unidentified article dated January 18, 1954, quotes the *New York Times* as saying of Wilson's work, "His intense colors and simple outlines invest his figures with almost heroic proportions and great simple dignity."[28]

Religion has always played a central role in the culture of African Americans from their African roots through slavery and into the twentieth century. As many social scientists have noted, the black church is the one institution black society has controlled, often instituting self-help organizations to take care of needy members. The Second Christian Church of Mayfield played an important role in the life of the Wilson family, and Ellis Wilson's belief in the centrality of religion in black culture originated in experiences at the church. The subject of his father Frank Wilson's painting, which hung in his barbershop, was Christ chasing the moneylenders out, suggesting strong religious faith. Like his father, Ellis Wilson was to produce paintings with religious themes. Religion, which was inextricably entwined with family in Wilson's view, is represented in his work in a number of forms—a portrayal of a church service in his hometown, a representation of the African Saint Benedict, a funeral in the Gullah region,[29] and a voodoo ritual in Haiti. The underlying themes are the same—the distinctive cultural characteristics of black religion.

Family members have described the portrait of Wilson's mother as depicting her in a church setting, suggesting the close connection between his mother and the church she founded. *Sunday Morning Service, Mayfield, Ky.* closely resembles the interior of "Mrs. Minnie's Church," the service in progress with a choir singing, a preacher stretching out his arms, and people kneeling in the foreground.[30] Wilson also sketched and later painted in oil Mayfield's Wooldridge monuments located in the Maplewood Cemetery (*Kentucky Graveyard,* c. 1939). A July 1938 article in *Art Digest* describes Wilson's painting *Peace* as showing black evangelist Father Divine "in transfiguration."[31] Perhaps the influence of religion in the early years of his life was inspiration for religious triptychs that Wilson was commissioned to paint during World War II. One titled *St. Benedict the Moor* depicted the black saint holding a crucifix with a black soldier on his left and on his right, kneeling toward him, heads bowed. Another triptych was of Christ carrying a crucifix, and a third portrayed a black

Madonna and child. An article in the February 3, 1943, issue of the *Brooklyn Eagle* commented: "Ellis Wilson's contemporary conception of a colored Madonna democratizes the Christ idea to the point of unlimited spiritual freedom."[32] *Three Nuns* is a portrait of three figures in ecclesiastic robes, while *Charleston Sisters* is a painting of two nuns silhouetted against a city street.

Wilson's interest in religion and worship continued in Haiti. In 1955, he was inspired to paint *Janvallou (2)*, which he described in a letter to Justus Bier as a "dance—danced during the ceremony of Voodoo."[33] The colorfully dressed figures in the painting are bending and swaying in front of a dark woods that is strung with lights. In his most popular painting, *Funeral Procession* (plate 23), Wilson's silhouetted mourners convey a somber sense of loss as they participate in the solemn religious ceremony. From his earlier depiction of a lively church service in Mayfield to the dignified presentation of a Haitian funeral, Wilson reminds the viewer that religion is a universal and enduring theme in black cultures.

ELLIS WILSON left behind few written or spoken words that expressed his views on the themes in his paintings; however, the motifs of family, work, and religion can be traced to his cultural roots in Mayfield, Kentucky. His family relationships in both his nuclear and his extended families were significant influences that shaped his values and the manner in which he perceived the social and physical environment. For him, the black family was a master institution for African Americans, and, along with religion and hard work, a source of group strength and support, and even artistic inspiration.

Wilson considered a small exhibit in the public library of his hometown of Mayfield in 1947 to be "one of the high points of his life."[34] At a time in Kentucky's history when blacks were prohibited from attending white colleges in the state, nearby Murray State College purchased Wilson's painting *End of the Day* in 1950 and in 1952 hosted an exhibition of his work. Louisville's J.B. Speed Museum exhibited Wilson's work in 1948.

It is fitting that before his death in New York in 1977, one of the last exhibits of Wilson's work was a small show at the Second Christian Church in the Bottom community where he grew up. The program included a tribute to the Mayfield Colored Graded School, the first educational institution he attended. There, Ellis Wilson was honored by those who knew him best in the place that had helped to shape him as a man and an artist.

NOTES

The authors would like to thank the following individuals for providing support and/or information on this project: Ms. Lura Mae Emerson, Mr. James Wilson, Ms. Alice Wilson, Mr. James W. Ligon, Ms. Mayme Lynn, Dr. Joseph Cartwright, Dr. Frank Elwell, and Dr. Lillian Daughaday. All interpretations and conclusions are the authors'.

1. A number of personal interviews were conducted with the relatives of Ellis Wilson, including his nephew James Wilson, niece Alice Wilson, and sister-in-law Ms. Jenny Wilson. Ms. Lura Mae Emerson, a childhood friend in her nineties, and two long-time friends in New York, Mr. James Ligon and Mr. Dean Finke, were also interviewed. A few elderly black residents of Mayfield, including Ms. Mayme Lynn,

who had knowledge about the history of the black community provided information.

2. Mainstream is generally understood to mean white, specifically those of the group who wield most of the economic and political power in American society. It is assumed by social scientists specializing in the investigation of African Americans that the family and religious institutions, mainly churches, are structures that have somewhat different patterns as compared with similar structures used primarily by whites. Social isolation over generations and the influence of the West African cultural heritage are two of the factors that are said to be responsible for the differences between black and white institutions. Obviously, there are also some similarities shared by white and black social structures.

3. Camille Billops, interviewer. "Ellis Wilson, Visual Artist." Oral history interview, February 25, 1975. *Artists and Influences*, vol. 12, 1994. (N.Y.: Hatch Billops Archives), 213.

4. In the early 1900s, a few black-owned businesses operated "up town" in the white controlled business section of Mayfield, among them a blacksmith shop that catered only to blacks and a barbershop that was located in the white-owned Hall Hotel that catered to whites only. By the 1940s, these businesses were gone. Today four black-owned businesses exist in the city of Mayfield, none related to ones that existed in the earlier mentioned period.

5. Billops, 213.

6. Ibid.

7. Mayfield's Colored Graded School closed in 1921, and the building still stands; a 92 year old classmate of Wilson resided there until 1999.

8. This information was taken from the most recent and most authoritative study on African American families: Andrew Billings. *Climbing Jacob's Ladder: The Enduring Legacy of African-American Families*. (N.Y.: Touchstone, Simon and Schuster, 1992).

9. The concept of black culture is an anthropological formulation, consisting of customary behaviors and perceptions of primarily African Americans in this case as well as other peoples of African descent. It is assumed that black culture possesses some unique elements, mostly those derived from the West African cultural heritage, and elements shared with the larger American society in which the black subsociety is embedded.

10. Billops, 214.

11. Sharon F. Patton. *African-American Art* (N.Y.: Oxford University Press, 1998), 110.

12. The Chicago riot of 1919 was part of a series of racial disturbances that involved marauding bands of whites attacking and killing blacks for the most part. The most famous of these riots occurred in 1917 in East St. Louis, Illinois, where some 300 blacks and less than twenty whites were killed. Fear of blacks as economic competitors and a history of racial hatred are cited in the social science literature as two of the causes of the riots.

13. According to Patton (109), the term the "New Negro" was coined by Howard University Professor Alain Locke in 1925 to describe African Americans who were experiencing a renewed racial pride associated with economic improvements and positive cultural identity. New Negro artists were striving for respect as visual artists and a way to express their racial heritage as well as a way to describe their distinct African American experience in American society.

14. A cultural nationalist is one who extols the virtues of his or her traditional culture over those elements that are associated with western culture generally or a specific western society. In the case of Alain Locke, he promoted the virtues (as he

perceived them) of traditional African culture, arguing that they were equal to or in some cases superior to those of American culture.

15. In the Archives of American Art, Ellis Wilson papers, microfilm roll no. 3, there is a letter written by Locke to Ellis Wilson congratulating him on his Guggenheim award.

16. Bearden and Henderson, 119.

17. Patton, 158.

18. Porter and Locke had a sustained debate about the content of "Negro Art" and from where black artists should draw their inspiration. This debate is complicated in terms of its relationship to art history, history, and political ideology related to black nationalism and assimilation into American culture. What is provided here is a simplified overview. Porter adopted the position that black artists should draw their inspiration from their own experiences in American culture, where they were born and bred; in other words, rely on what they experienced first hand. Locke, on the other hand, took the position that a distinctive "Negro art" should be derived from the "ancestral arts" that he believed were rooted in traditional African culture. In his article "The Legacy of the Ancestral Arts," he stressed that most African American artists of the day (1920s) found it very difficult to openly acknowledge the African cultural heritage because of the negative conditioning they received regarding the putative inferiority of African ways of life. Locke demonstrated that African art had significantly influenced European art and had the potential of stimulating the creation of a culturally distinctive style for black artists. See Alain Locke, *The New Negro* (New York: A. and C. Boni, 1925).

19. Bearden and Henderson, 340.

20. Billops, 213.

21. Bearden and Henderson, 337. In addition, Wilson may or may not have been aware of a black man who, in 1906 in Mayfield, was accused of rape and tried and executed in a proceeding that lasted a total of forty-two minutes. See James C. Klotter, *Kentucky: Portrait in Paradox, 1900-1950* (Frankfort, Ky.: Kentucky Historical Society, 1996), 67.

22. Archives of American Art, Ellis Wilson papers, microfilm roll no. 3.

23. Ibid.

24. Justus Bier, "Ellis Wilson, Kentucky Negro Artist," *The Courier-Journal Magazine*, Louisville, Ky., April 30, 1950, 39.

25. Ibid.

26. Bearden and Henderson, 342.

27. Senta Bier, "Art: Paintings by Ellis Wilson Shown in New York," *The Courier-Journal*, Louisville, Ky., February 14, 1954.

28. Newspaper clipping, Archives of American Art, Ellis Wilson papers, microfilm roll no. 3.

29. *Edisto Island Funeral* is listed as a title of Ellis Wilson's painting in *Against the Odds: African American Artists and the Harmon Foundation*, The Newark Museum, 1982, 272.

30. Image of painting can be found in Archives of American Art, Ellis Wilson papers, microfilm roll no. 3.

31. Newspaper clipping, Archives of American Art, Ellis Wilson papers, microfilm roll no. 3.

32. Images of triptychs and newspaper clipping can be found in Archives of American Art, Ellis Wilson papers, microfilm roll no. 3.

33. Letter from Wilson to Justus Bier was found on file at University of Louisville; the painting *Janvallou II* is part of U of L's art collection.

34. Bearden and Henderson, 337.

CURATOR'S ESSAY

Albert F. Sperath

MY BACKGROUND AND EXPERIENCE as a curator is not traditional. I am not an art historian but rather a studio artist who began curating exhibitions because of my goal of becoming an art museum professional. The Ellis Wilson retrospective is my first effort at organizing and selecting work from one artist on a national scale. The experience has been exhilarating and exhausting.

Ellis Wilson is a lesser known artist whose work—literally and figuratively—has not survived as well as some of his more famous peers. Some of the materials he used were of poor quality or incompatible in conservator's terms, causing the work to deteriorate, in some cases to the point of being unrecognizable. And his relative obscurity in the mainstream (white) art gallery world likely aided in the disappearance of much of his work. His death in 1977 with no heirs contributed to that obscurity, although his friends were able to save his art and his reputation.

Wilson was relatively prolific. During my research of titles in published articles, biographies, applications, and catalogues, I discovered more than 270 (not including works on paper or sculpture). That number is significant considering that Wilson never made a living solely from his art. My goal was to locate about forty-five works for a traveling exhibition that would, of course,

provide the overview a retrospective requires. I began with a list of about thirty-five pieces, provided by David P. Duckworth, but I obviously needed a wider selection from which to select the best surviving and rediscovered paintings. I also had a goal of producing a painting catalogue raisonné.

The task has been complicated by the fact that Wilson rarely dated or titled his paintings, although almost every one is signed. According to Margaret Vendryes, there is a school of thought that suggests that painters did not date their works during this time because they wanted clients to perceive their works as new and fresh and not as the previous years' offerings. I have found paintings listed and reproduced with different titles in different shows. Often Wilson would make several versions of the same scene, sometimes with indiscernible or subtle differences and other times with dramatic departures. In one instance I have found three versions of the same still life.

For these reasons I had to become a detective. I was faced with putting together a puzzle for which the boxtop showing the entire picture was gone and from which many of the individual pieces were missing as well. I had to use the image of a work as the key, not the title, and I had to watch for duplicates and derivatives. This monograph reflects the best that I, with the help of many, could do.

Modifications or even corrections are inevitable and will no doubt come to light after this project receives public scrutiny.

I have concentrated my research on Wilson's oil paintings. I approached the project from a studio artist's perspective, selecting art representative of periods in his life and not concerning myself with his contacts and influences. To my advantage was the fact Wilson was mentioned in most of the African American artist biographies, and many times a piece of his work was reproduced therein.

In the summer of 1998 I spent five weeks on the road visiting as many collectors, collections, friends, and acquaintances of Wilson's as possible. As I examined his work and learned about him from his close friends, I began to get a feeling of who he was. I also began to see the linear progression of his art. His work can be categorized according to several discreet periods in his life, and these periods correspond directly with important monetary awards.

Prior to his Guggenheim Fellowship, Wilson concentrated on the city scenes and people-scapes of New York (of which there are very few remaining), family portraits, and Kentucky scenes. The series of black factory workers he painted in the early forties ended his early period, and the South Carolina series began his middle period. After his visits to the southeast, he shows fewer people in his works, and the people he does depict are less active and less realistic. The third, or late, period begins with Wilson's visits to Haiti. Even though he had showed his love for color before, in his later paintings it becomes even more vivid and the people he paints become less so.

Interestingly, some of Wilson's paintings defy the changes I note in style—his still lifes. Throughout his career he painted them with little or no change in technique. One could surmise they were made to please himself or to sell. They seemed to satisfy something within the artist. Perhaps, as Margaret Vendryes notes, they represent the pleasure he found "in recording small corners of life over which he exercised some control."

In 1952, Ellis Wilson's work was shown in a one-person exhibition at Mary Ed McCoy Hall gallery at Murray State University. At the time—a time in Kentucky's history when, as Steven Jones and Eva King point out, blacks were not allowed to attend white colleges in the Commonwealth—it was the only gallery on campus. Though the old gallery was abandoned with the opening of the Clara M. Eagle Art Gallery in 1971, it seems particularly fitting that a major retrospective of Wilson's work should be held at Murray State, twenty-five miles from Mayfield, Kentucky.

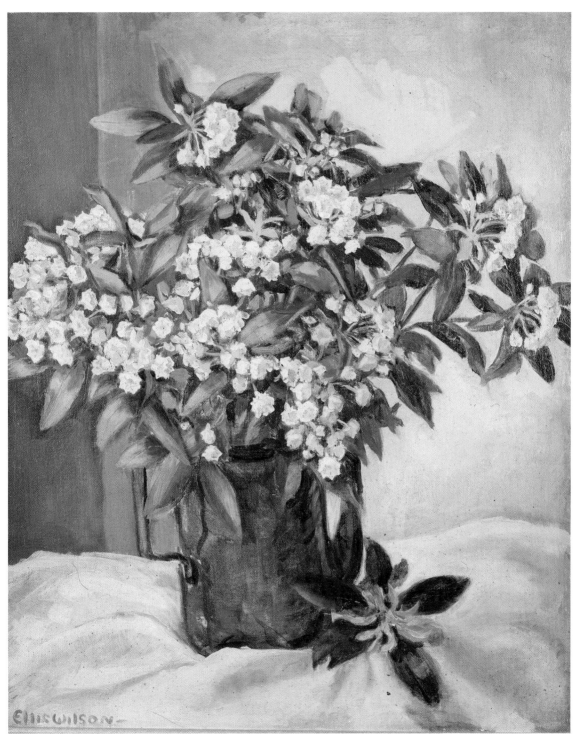

1

Chinese Lily, c. 1934
Oil on canvas
32 × 28 inches
Signed LL
DuSable Museum of African-American History, Inc., Chicago, Illinois

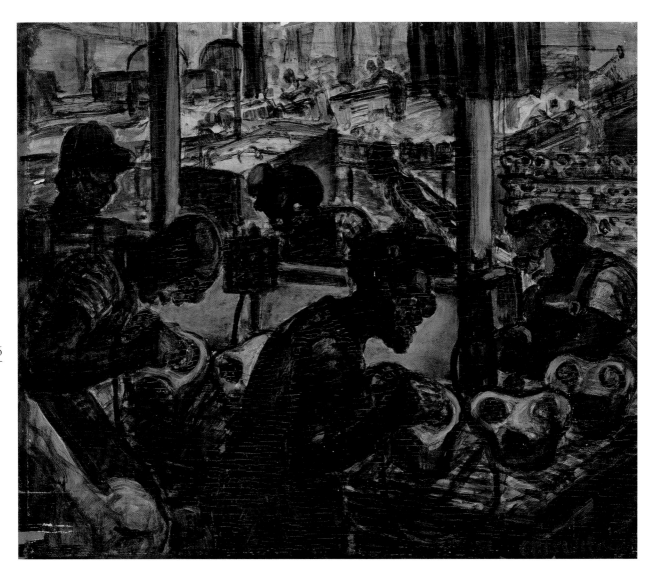

2

Burr Bench, Defense Workers, Workers, before 1944
Oil on wood
20 × 24 inches
Signed LR
David King Dunaway, New Mexico

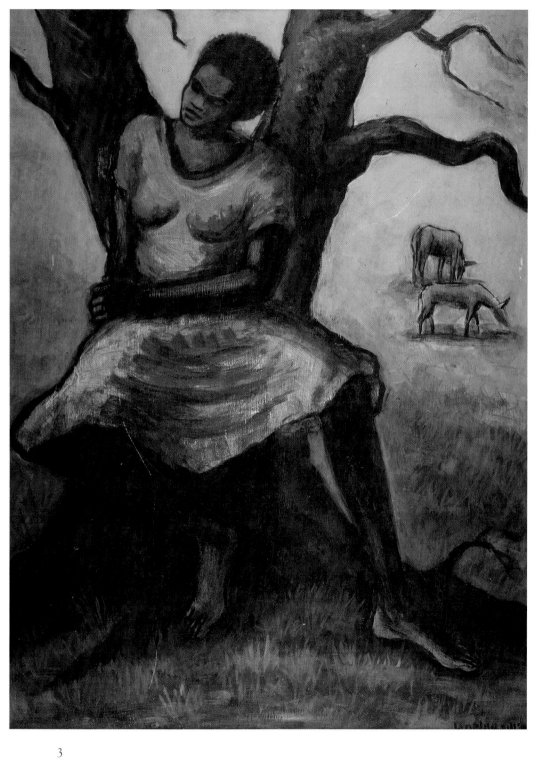

3

Woman in a Red Dress, Girl in a Red Dress, c. 1944
Oil on composite board
24 × 18 inches
Signed LL
Aaron Douglas Collection, Amistad Research Center, Tulane University, New Orleans, Louisiana

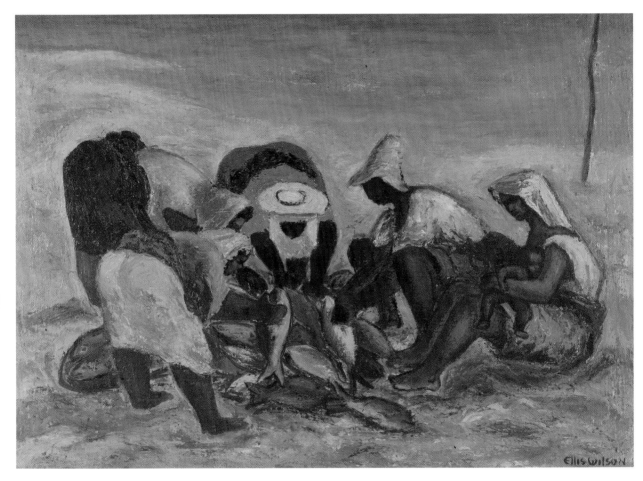

4

Fishermen's Wives, c. 1945
Oil on canvas
35.5 × 46.5 inches
Signed LR
Howard University Gallery of Art, Washington, D.C.

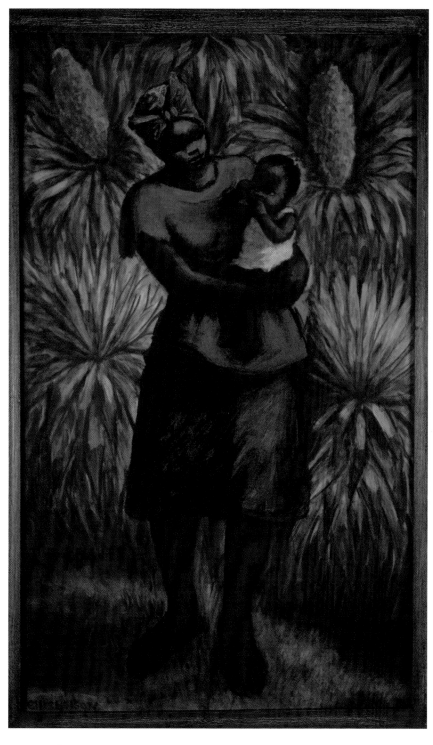

5

Mother and Son, Woman with Boy, c. 1944
Oil on composite board
24 × 14.5 inches
Signed LL
Alice Wilson, New Jersey

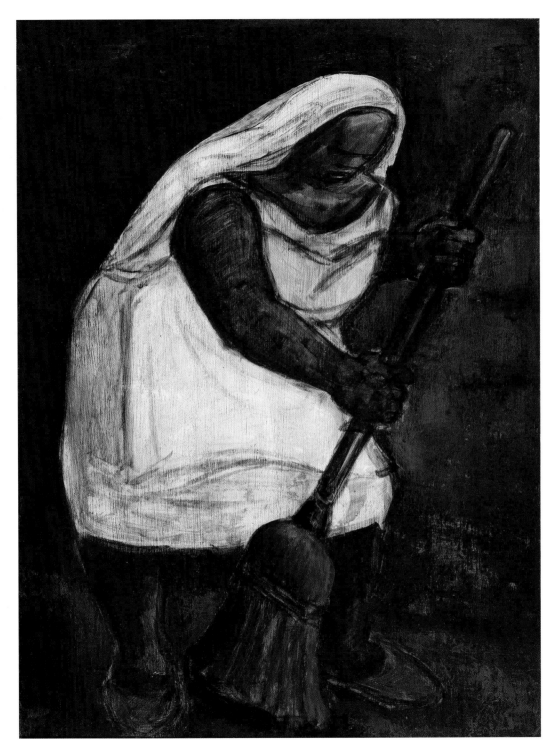

6

Woman Sweeping, Sweeping, 1945
Oil on composite board
23.5 × 17.5 inches
Not signed
Harmon and Harriet Kelley Collection of African American Art, Texas

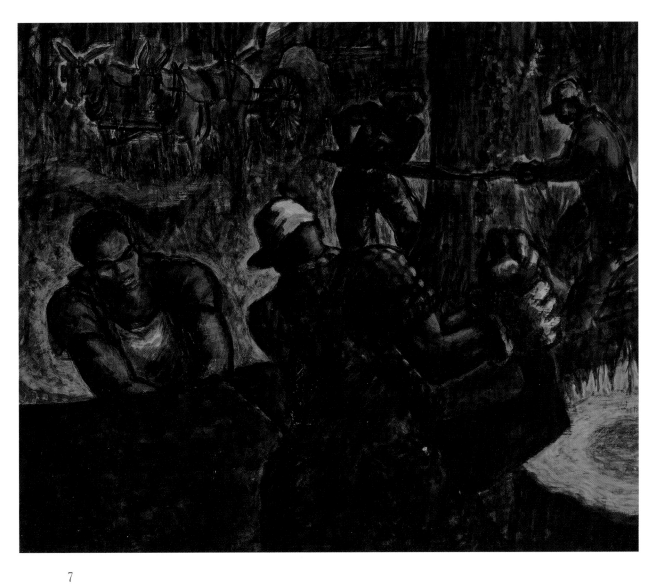

7

Lumberjacks, 1944-45
Oil on composite board
25 × 30 inches
Signed LL
Speed Art Museum, Louisville, Kentucky; gift of Mr. and Mrs. Jonathan King

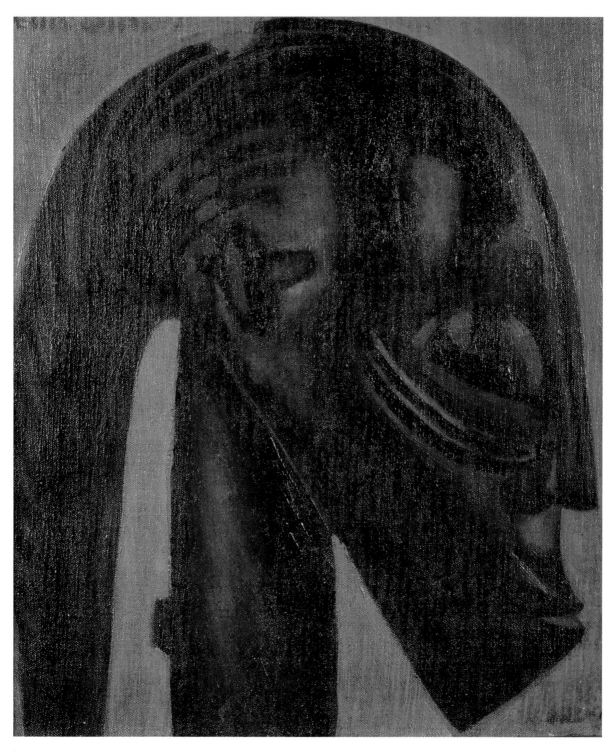

8

African Mask, c. 1945
Oil on canvas
16.75 × 14 inches
Not signed
DuSable Museum of African-American History, Inc., Chicago, Illinois

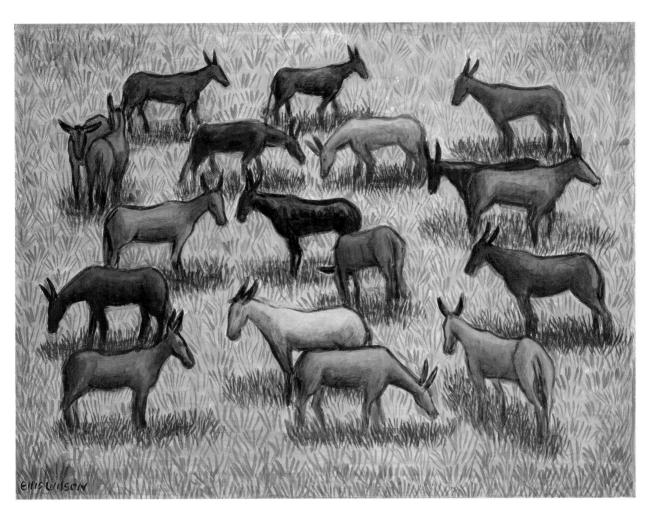

9

South Carolina Mules, Mules, c. 1945
Oil on board
20 × 24 inches
Signed LL
Greenville County Museum of Art, Greenville, South Carolina; gift of halley k. harrisburg and Michael Rosenfeld, New York

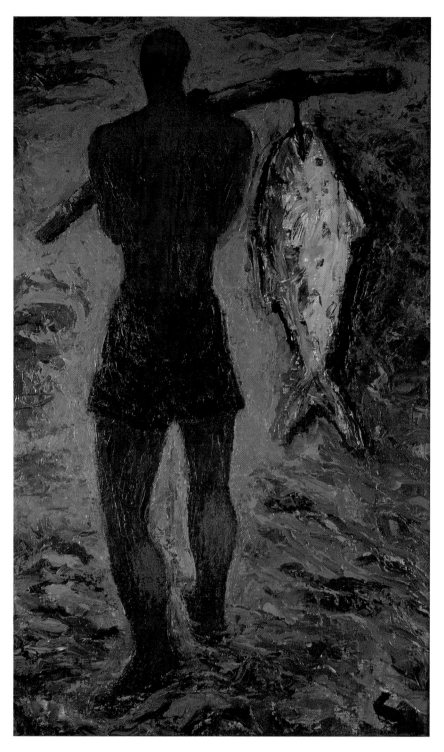

10

End of the Day, Man with a Fish, Fisherman, c. 1945
Oil on plywood
29 × 17.5 inches
Signed LR
Murray State University, Murray, Kentucky

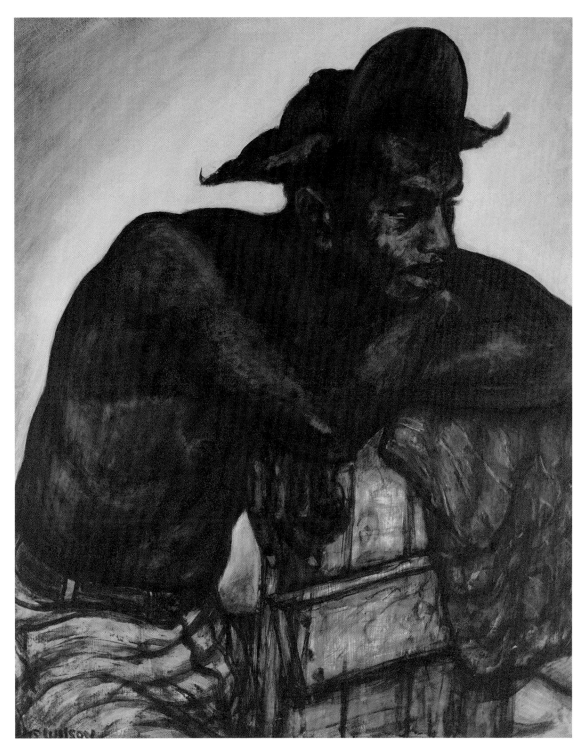

11

Allen, 1945
Oil on composite board
29.5 × 24.5 inches
Signed LL
Clark-Atlanta University Collections, Atlanta, Georgia

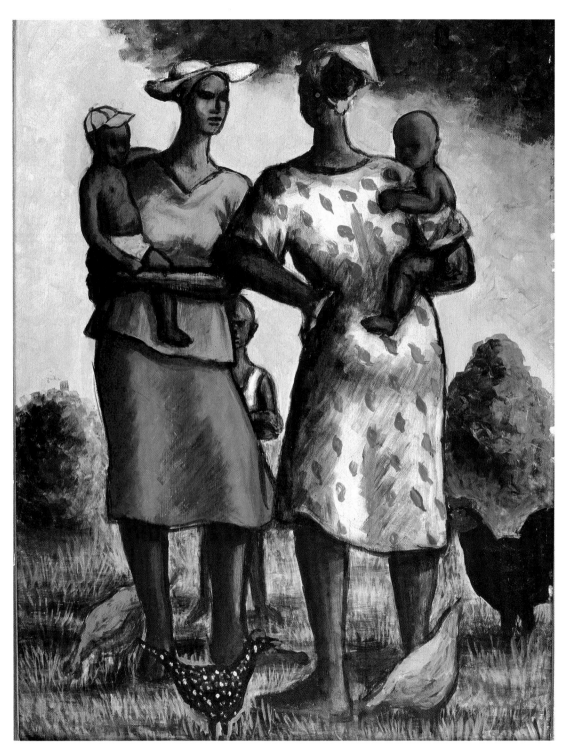

12

Two Mothers, Mothers with Children, On the Plantation, c. 1946
Oil on composite board
28 × 20 inches
Not signed
Howard University, Gallery of Art, Washington, D.C.

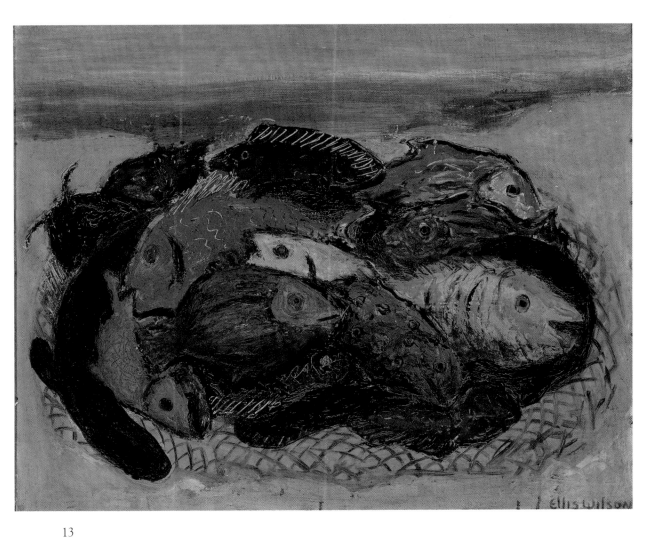

13

Catch, Fishies, before 1947
Oil on wood
19.5 × 25.5 inches
Signed LR
David King Dunaway, New Mexico

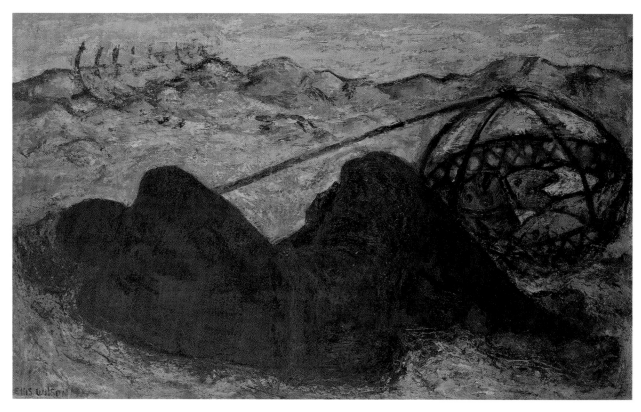

14

Figure on Beach, c. 1947
Oil on composite board
22 × 36 inches
Signed LL
Owen Dodson Collection, Bates College, Lewiston, Maine

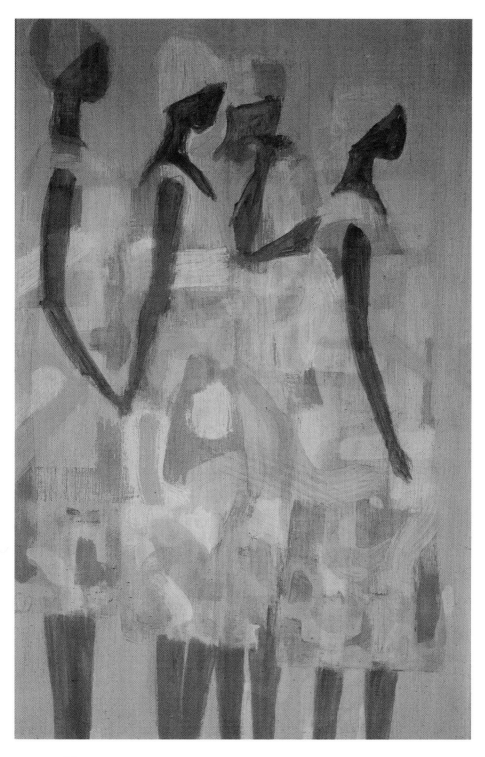

15

Sisters, c. 1948
Oil on composite board
36 × 24 inches
Signed LR
James Ligon and Dean Finke, New York

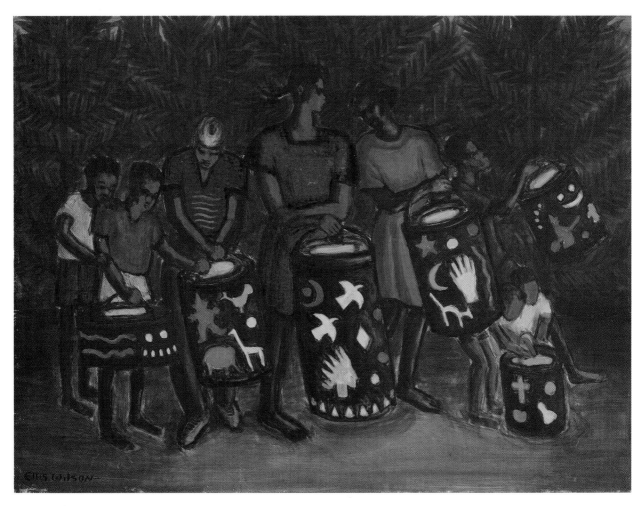

16

People with Drums, Musicians, n.d.
Oil on composite board
18 × 24 inches
Signed LL
Fisk University Art Galleries, Nashville, Tennessee

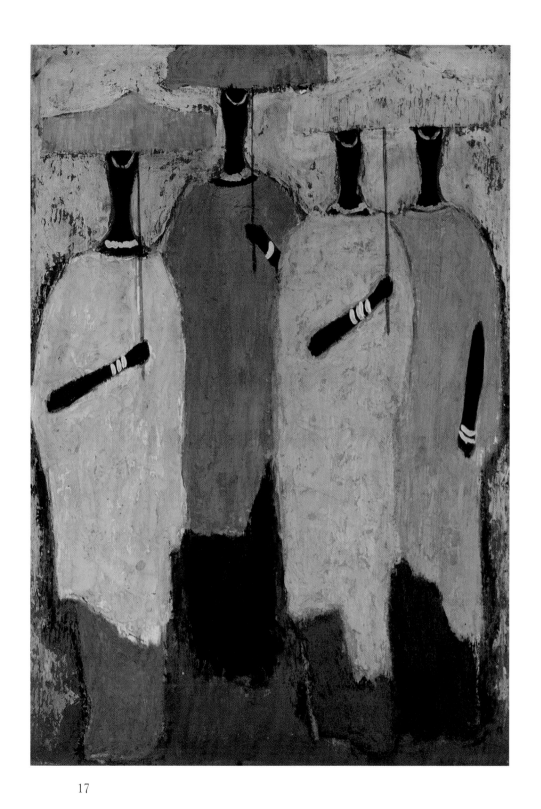

17

African Princesses (four women), c. 1950
Oil on composite board
31 × 22 inches
Signed LR
Dorothy Kohnhorst Hodapp, Kentucky

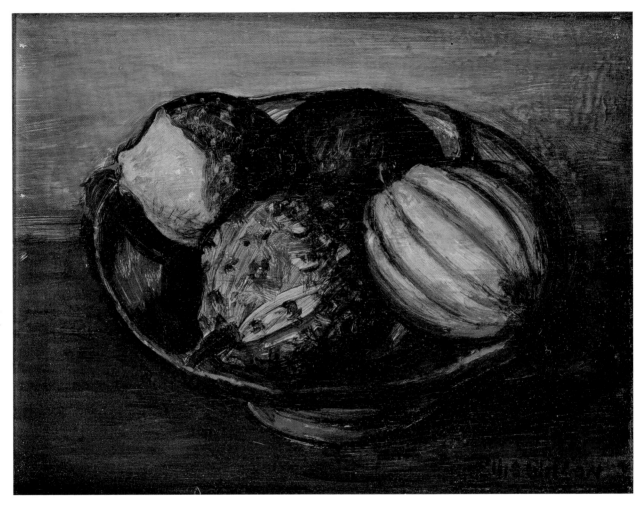

18

Still Life with Fruit (vegetables), c. 1950
Oil on board
9.5 × 12.5 inches
Signed LR
Michael Rosenfeld Gallery, New York, New York

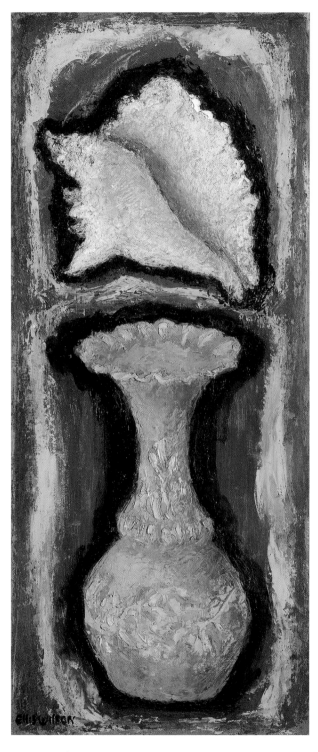

19

Blue Vase, Shell and Blue Vase, c. 1951
Oil on composite board
27.5 × 12 inches
Signed LL
Fisk University Art Galleries, Nashville, Tennessee

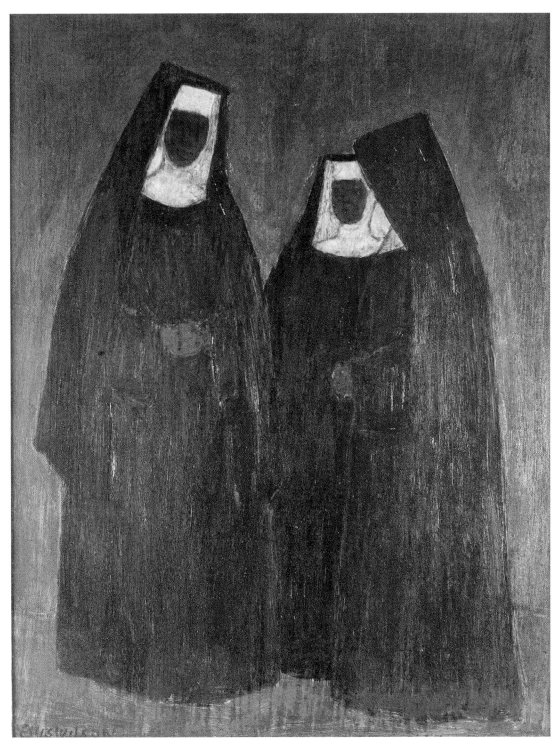

20

Nuns, c. 1951
Oil on composite board
26 × 20 inches
Signed LL
James Ligon and Dean Finke, New York

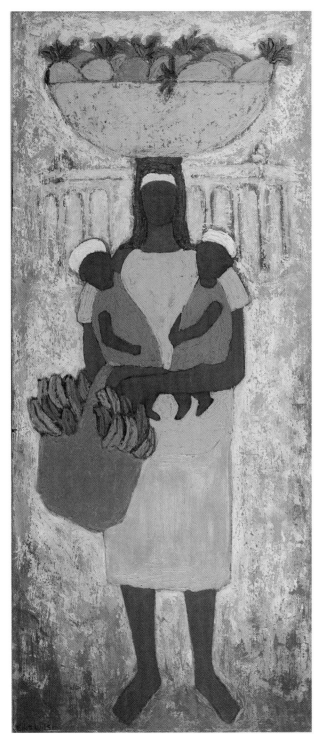

21

Marchande (woman vendor with two children in arms), n.d.
Oil on pressed paperboard
46 × 20 inches
Signed LL
Jerry Allford, Connecticut

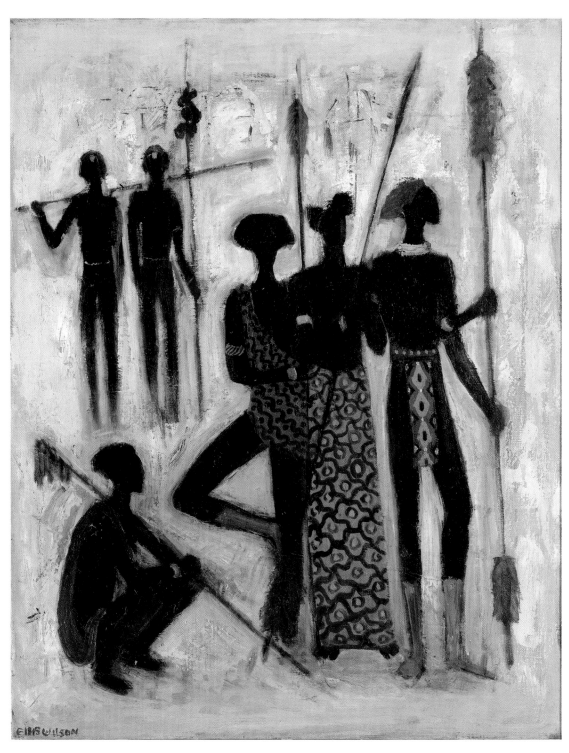

22

Tribal Scene, c. 1950
Oil on canvas
35 × 28 inches
Signed LL
Schomburg Center for Research in Black Culture, Art and Artifacts Division, New York Public Library;
Astor, Lenox, and Tilden Foundations

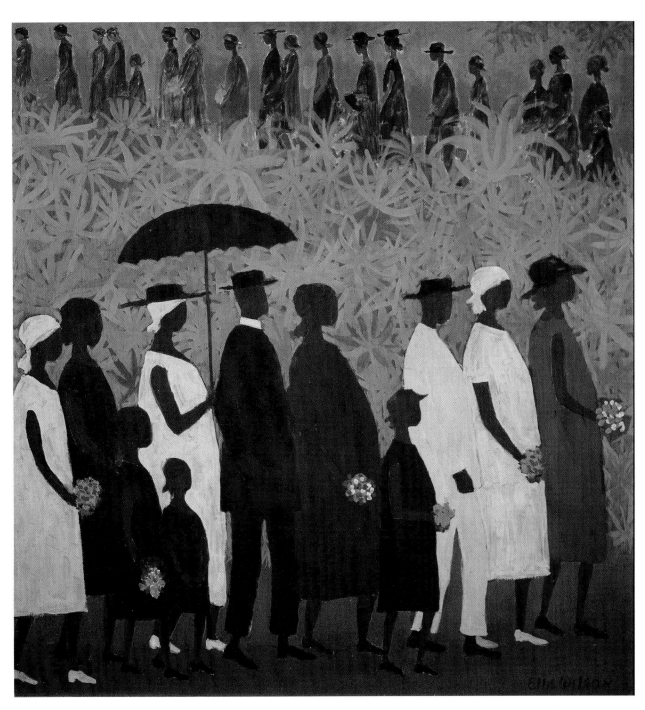

23

Funeral Procession, Haitian Funeral Procession, Peasant Funeral, Procession, Processional, c. 1950s
Oil on composite board
30.5 × 29.25 inches
Signed LR
Aaron Douglas Collection, Amistad Research Center, Tulane University, New Orleans, Louisiana

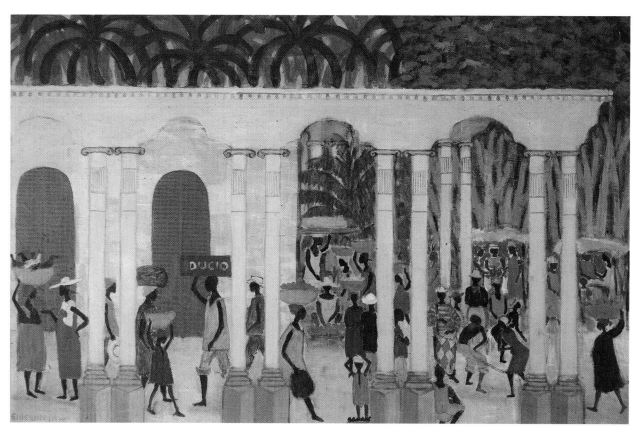

24

Colonade, Promenade, c. 1952
Oil on composite board
24.5 × 37.5 inches
Signed LL
James Ligon and Dean Finke, New York

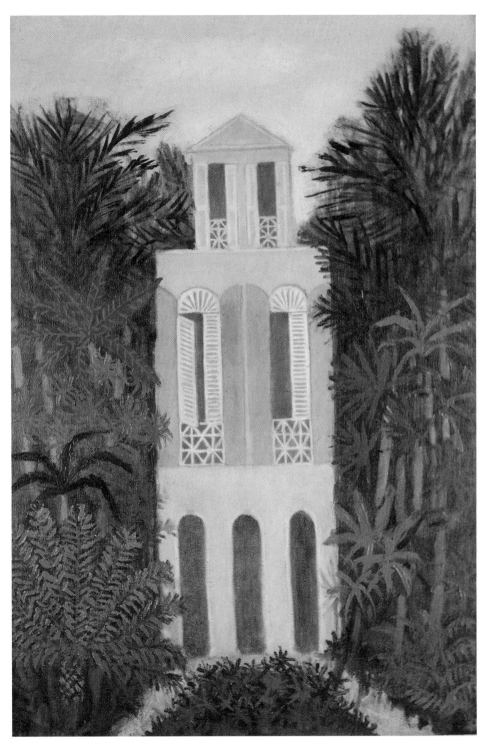

25

Pink Villa, c. 1954
Oil on canvas
29 × 20 inches
Signed LL
Hampton University Museum, Hampton, Virginia

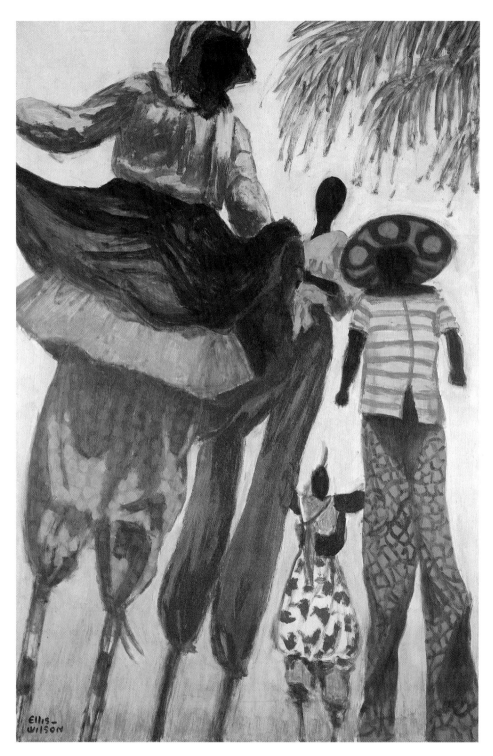

26

Stilt Walkers, n.d.
Oil on composite board
42 × 28 inches
Signed LL
Michael Rosenfeld Gallery, New York, New York

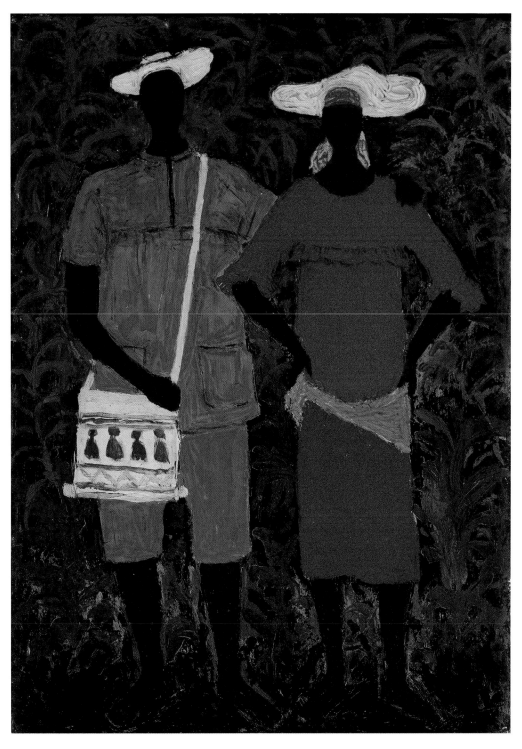

27

Jamaican Paysans, n.d.
Oil on composite board
16 × 14.25 inches
Signed LL
Speed Art Museum, Louisville, Kentucky; bequest of Murah Pace Culter

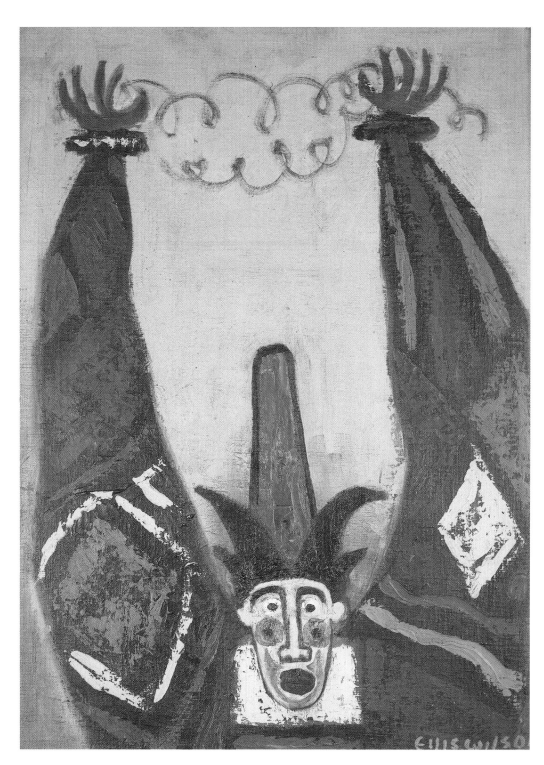

28

Harlequin (jester with arms upraised), n.d.
Oil on linen on paper board
24 × 18 inches
Signed LR
Melvin Holmes, California

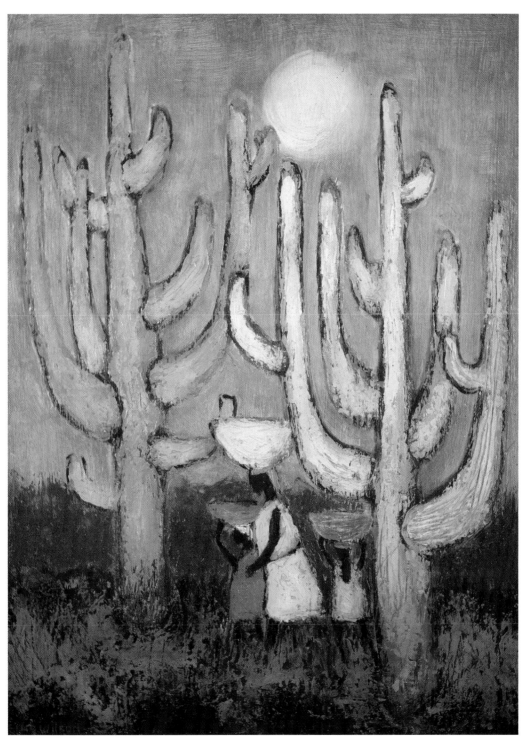

29

Haitian Scene, c. 1953
Oil on composite board
24 × 17.75 inches
Signed LL
Private collection, Pennsylvania

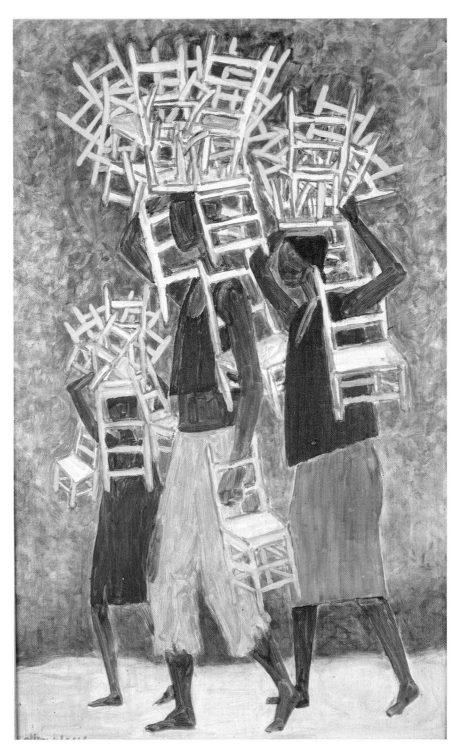

30

Chair Vendors, Haiti, 1965
Oil on composite board
28.25 × 17.5 inches
Signed LL
Rose Art Museum, Brandeis University, Waltham, Massachusetts

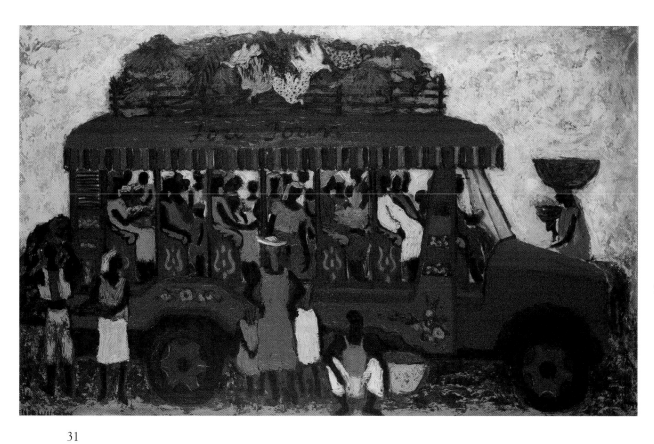

31

Camion (Fou Foun Bus), c. 1953
Oil on panel
27 × 40 inches
Signed LL
Robert and Lillian Ross, New York

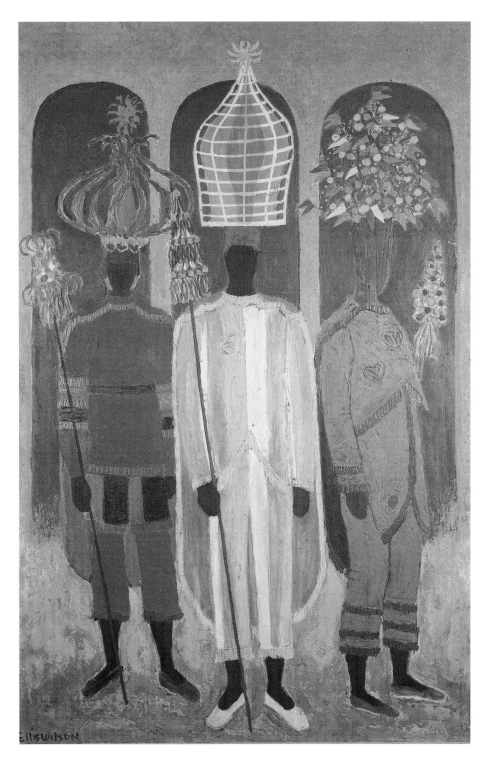

32

Three Kings (2), c. 1954
Oil on composite board
36 × 24 inches
Signed LL
June and Walter Christmas, New York

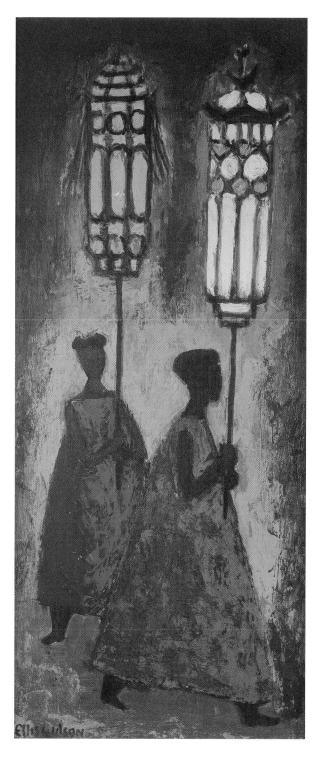

33

Women with Lanterns, Two Women with Lanterns, c. 1954
Oil on composite board
27.75 × 12.5 inches
Signed LL
I.P. Stanback Museum and Planetarium, South Carolina State
University, Orangeburg, South Carolina

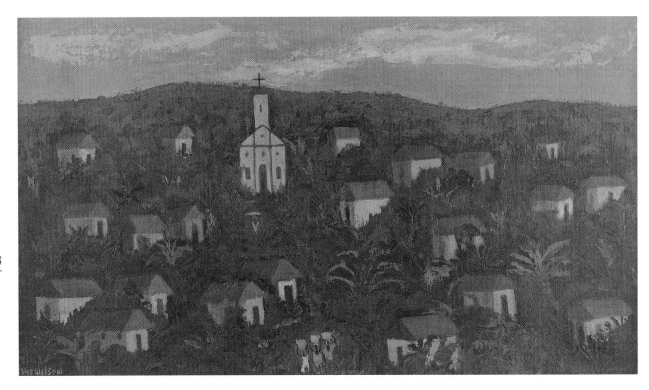

34

Haitian Village (three women in foreground), c. 1954
Oil on composite board
25.5 × 24 inches
Signed LR
Fannie Etta and James T.L. Dandridge, Maryland

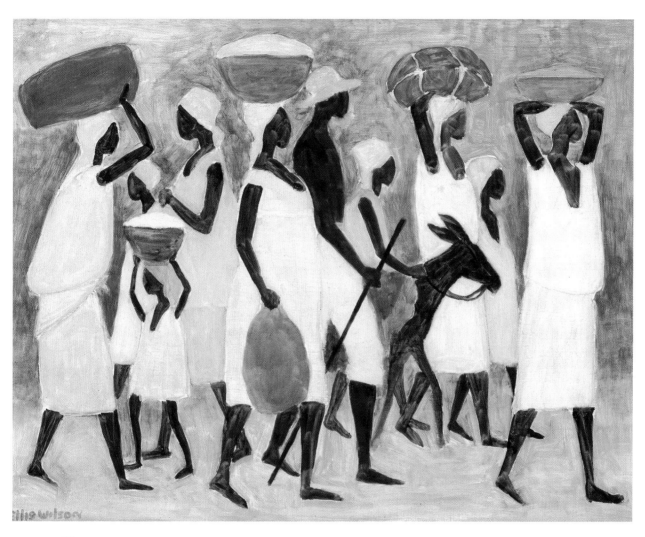

35

To Market, Haitian Peasants, c. 1954
Oil on panel
22.5 × 28.75 inches
Signed LL
North Carolina Museum of Art, Raleigh; museum purchase, special gift fund

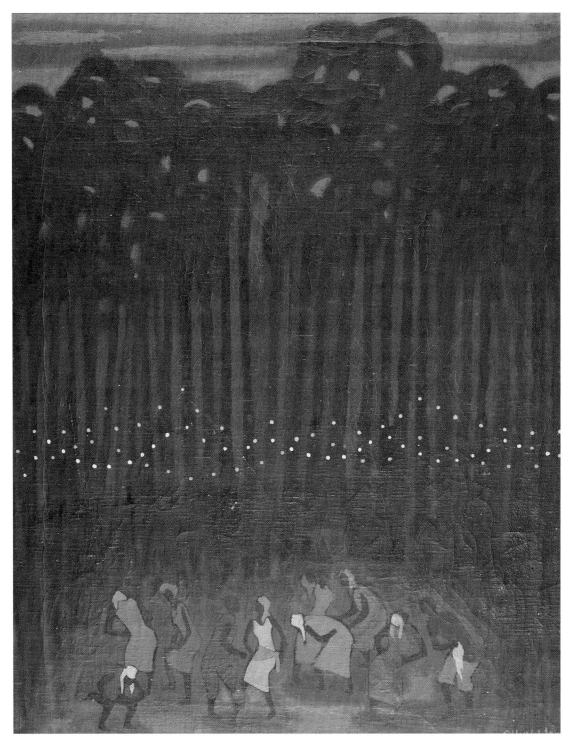

36

Janvallou (2), 1955
Oil on canvas
29.5 × 23.5 inches
Signed LR
University of Louisville, Louisville, Kentucky

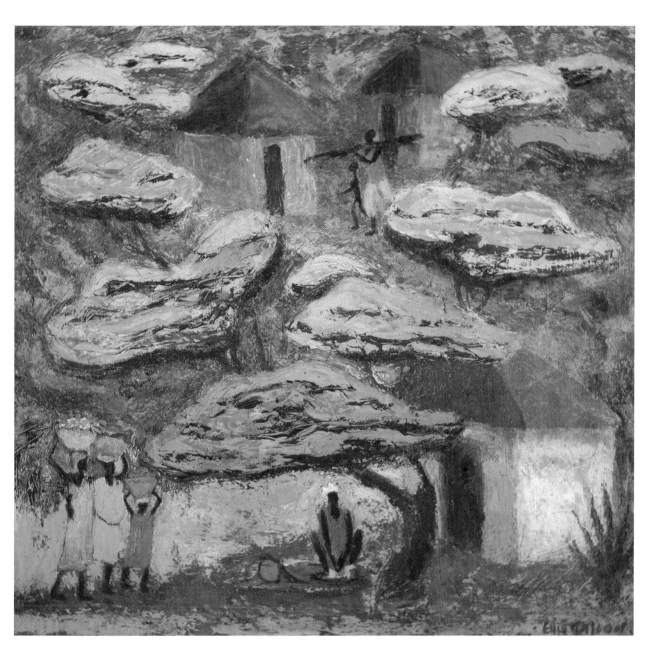

37

Haitian Village (pink/lavender trees), c. 1955
Oil on panel
24 × 25.5 inches
Signed LR
Private collection, Pennsylvania

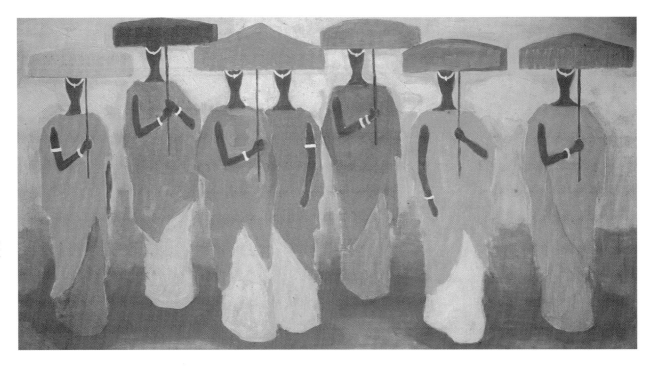

38

African Royalty, c. 1950
Oil on composite board
19 × 38 inches
Not signed
James Ligon and Dean Finke, New York

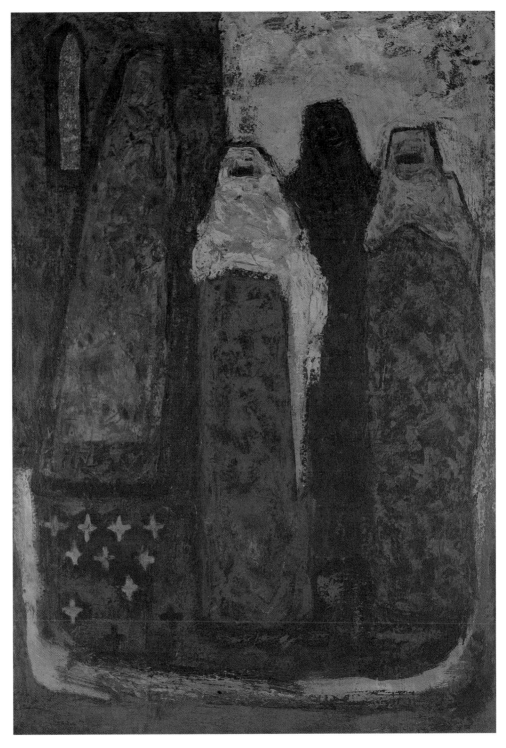

39

Women in Purdah, c. 1962
Oil on linen
29 × 20 inches
Signed LL
David King Dunaway, New Mexico

40

Still Life, n.d.
Oil on canvas on board
9 × 12 inches
Signed LR
I.P. Stanback Museum and Planetarium, South Carolina State University, Orangeburg, South Carolina

41

Still Life, n.d.
Oil on composite board
11.5 × 13.5 inches
Signed LR
Fannie Etta and James T.L. Dandridge, Maryland

CATALOGUE RAISONNÉ

Compiled by Albert Sperath and Eva King

When a work has been called by more than one title, the title preferred by the current owner is listed first, followed by the alternate titles. Where titles are identical for more than one work, a description or sequential number of the work appears in parentheses following the title. All dimensions are given in inches, not including the frame, and height precedes width. The signature is always ELLIS WILSON, in printed form, unless noted otherwise. Composite board, on which Wilson often worked, is Masonite or a similar product.

LOCATED WORKS

African Mask, c. 1945
Oil on canvas
16.75 × 14 inches
Not signed
DuSable Museum of African-American History, Inc., Chicago, Illinois

African Princesses (four women), c. 1950
Oil on composite board
31 × 22 inches
Signed LR
Dorothy Kohnhorst Hodapp, Kentucky

African Royalty, c. 1950
Oil on composite board
19 × 38 inches
Not signed
James Ligon and Dean Finke, New York

Allen, 1945
Oil on composite board
29.5 × 24.5 inches
Signed LL
Clark-Atlanta University, Atlanta, Georgia

Bananas, c. 1950
Oil on canvas on paper board
20 × 24 inches
Signed LR
James Ligon and Dean Finke, New York

Blue Vase, Shell and Blue Vase, c. 1951
Oil on composite board
27.5 × 12 inches
Signed LL
Fisk University, Nashville, Tennessee

Burr Bench, Defense Workers, Workers,
before 1944
Oil on wood
20 × 24 inches
Signed LR
David King Dunaway, New Mexico

Camion (Fou Foun Bus), c. 1953
Oil on panel
27 × 40 inches
Signed LL
Robert and Lillian Ross, New York

Caribbean Vendor, Bird Vendor, 1953
Oil on canvas
39 × 24 inches
Signed LL
Hampton University Museum, Hampton, Virginia

Catch, Fishies, before 1947
Oil on wood
19.5 × 25.5 inches
Signed LR
David King Dunaway, New Mexico

Chair Vendors, Haiti, 1965
Oil on composite board
28.25 × 17.5 inches
Signed LL
Rose Art Museum, Brandeis University,
Waltham, Massachusetts

Children, n.d.
Oil on canvas
22 × 32 inches
Signed TL verso
James Ligon and Dean Finke, New York

Chinese Lily, c. 1934
Oil on canvas
32 × 28 inches
Signed LL
DuSable Museum of African-American History,
Chicago, Illinois

Cock, c. 1950
Oil on linen
20 × 16 inches
Signed LL
Wadsworth Atheneum, Hartford, Connecticut

Colonade, Promenade, c. 1952
Oil on composite board
24.5 × 37.5 inches
Signed LL
James Ligon and Dean Finke, New York

End of the Day, Man with a Fish, Fisherman,
c. 1945
Oil on plywood
29 × 17.5 inches
Signed LR
Murray State University, Murray, Kentucky

Factory Worker, Salvaging, before 1943
Oil on board
22 × 18 inches
Signed LR
Hampton University Museum, Hampton, Virginia

Field Hands, before 1948
Oil on composite board
21 × 25 inches
Unknown
Private collection, New York

Field Workers, Tobacco Hands, Harvest, c. 1950
Oil on composite board
29.5 × 35 inches
Signed LL
National Museum of American Art, Washington,
D.C.

Figure on Beach, c. 1947
Oil on composite board
22 × 36 inches
Signed LL
Owen Dodson Collection, Bates College,
Lewiston, Maine

Fish (2), n.d.
Oil on canvas
20 × 24 inches
Signed LR
James Ligon and Dean Finke, New York

Fish (3), n.d.
Oil on pressed paper board
12 × 10 inches
Not signed
James Ligon and Dean Finke, New York

Fishermen's Wives, c. 1945
Oil on canvas
35.5 × 46.5 inches
Signed LR
Howard University Gallery of Art,
Washington, D.C.

Floral Still Life, c. 1950
Oil on composite board
20 × 16 inches
Signed LR
Mary Neale Barton, Kentucky

Flower Hat, n.d.
Oil on panel
14 × 11 inches
Not signed
Private collection

Flower Vendor, Flower Seller, Charleston Flower Vendor, 1945
Oil on composite board
30 × 26.25 inches
Signed LR
Barnett-Aden Collection, Robert Johnson,
Washington, D.C.

Flying Kite, before 1954
Oil on composite board
8.25 × 10.25 inches (approximate)
Unknown
Private collection, New York

Funeral Procession, Haitian Funeral Procession, Peasant Funeral, Procession, Processional, c. 1950s
Oil on composite board
30.5 × 29.25 inches
Signed LR
Aaron Douglas Collection, Amistad Research Center, Tulane University, New Orleans, Louisiana

Gardenia, n.d.
Oil on plywood
10.5 × 14 inches
Signed LL
James Ligon and Dean Finke, New York

Grapes and Melon, c. 1947
Oil on composite board
8 × 10.25 inches
Unknown
Studio Museum in Harlem, New York, New York

Haitian Camion (Belle Amour bus), 1953
Oil on composite board
19 × 28.75 inches
Signed LR
African American Center, Charlotte, North Carolina

Haitian Scene, c. 1953
Oil on composite board
24 × 17.75 inches
Signed LL
Private collection, Pennsylvania

Haitian Village (pink/lavender trees), c. 1955
Oil on panel
24 × 25.5 inches
Signed LR
Private collection, Pennsylvania

Haitian Village (three women in foreground), c. 1954
Oil on composite board
25.5 × 24 inches
Signed LR
Fannie Etta and James T.L. Dandridge, Maryland

Harlem Belle, before 1952
Oil on composite board
13.25 × 11 inches
Signed LR
Howard University Gallery of Art,
Washington, D.C.

Harlem Can Can, before 1941
Oil on panel
11 × 13 inches
Signed LR
Essie Green Gallery, New York, New York

Harlequin (jester with arms upraised), n.d.
Oil on linen on paper board
24 × 18 inches
Signed LR
Melvin Holmes, California

Hope, n.d.
Oil on board
22 × 11.5 inches
Unknown
Private collection, New York

Iron Market, before 1954
Oil
Unknown
Unknown
Private collection, New York

*Island Cemetery, Haitian Cemetery,
Island Cemetery, Haiti*, c. 1955
Oil on plywood
25 × 29 inches
Signed LR verso
Robert and Lillian Ross, New York

Jamaican Paysans, n.d.
Oil on composite board
16 × 14.25 inches
Signed LL
Speed Art Museum, Louisville, Kentucky

Janvallou (2), 1955
Oil on canvas
29.5 × 23.5 inches
Signed LR
University of Louisville, Louisville, Kentucky

Jeremiah, before 1948
Oil on composite board
29 × 22 inches
Signed LL
Hampton University Museum, Hampton, Virginia

Jester/Clown, n.d.
Oil on board
18 × 13.75 inches
Signed LL
Private collection, New York

Kentucky Graveyard, Wooldridge Monuments, 1939
Oil on linen
24 × 34 inches
Signed LR
Everhart Museum, Scranton, Pennsylvania

Lucille Ligon, n.d.
Oil on canvas on paper board
16 × 12 inches
Signed LL
James Ligon and Dean Finke, New York

Lumberjacks, 1944-45
Oil on composite board
25 × 30 inches
Signed LL
Speed Art Museum, Louisville, Kentucky

Marchande (woman vendor with two children in arms), n.d.
Oil on pressed paperboard
46 × 20 inches
Signed LL
Jerry Allford, Connecticut

Marchande (women and children in market), c. 1954
Oil on composite board
23 × 36 inches
Not signed
John and Maxine Ross, Virginia

Matriarch, 1947
Oil
31 × 24 inches
Signed LL
Barnett-Aden Collection, Robert Johnson,
Washington, D.C.

Mother and Son, Woman with Boy, c. 1944
Oil on composite board
24 × 14.5 inches
Signed LL
Alice Wilson, New Jersey

Nuns, c. 1951
Oil on composite board
26 × 20 inches
Signed LL
James Ligon and Dean Finke, New York

People with Drums, Musicians, n.d.
Oil on composite board
18 × 24 inches
Signed LL
Fisk University, Nashville, Tennessee

Pink Villa, c. 1954
Oil on canvas
29 × 20 inches
Signed LL
Hampton University Museum, Hampton, Virginia

Primavite [sic], c. 1951
Oil on composite board
12 × 24 inches
Signed LL
Private collection, New York

Shore Leave, 1941
Oil on composite board
16 × 20 inches
Signed LR
Aaron Douglas Collection, Amistad Research
Center, Tulane University, New Orleans,
Louisiana

Sisters, c. 1948
Oil on composite board
36 × 24 inches
Signed LR
James Ligon and Dean Finke, New York

South Carolina Mules, Mules, c. 1945
Oil on board
20 × 24 inches
Signed LL
Greenville County Museum of Art, Greenville,
South Carolina

St. Marc, Haiti, 1954
Oil
28.25 × 33 inches
Unknown
Private collection, New York

Still Life of Fruit in Bowl, n.d.
Oil on board
12 × 16 inches
Signed LL
Private collection, New York

Still Life with Fruit (vegetables), c. 1950
Oil on board
9.5 × 12.5 inches
Signed LR
Michael Rosenfeld Gallery, New York, New York

Still Life with Fruit, c. 1958
Oil on panel
11 × 24 inches
Not signed
Robert and Lillian Ross, New York

Still Life with Gourds, c. 1955
Oil on wood
7.25 × 8.25 inches
Signed LR
David King Dunaway, New Mexico

Still Life, 1933
Oil on board
8 × 10 inches
Unknown
Schomburg Center for Research in Black Culture, Art and Artifacts Division, New York Public Library; New York

Still Life, n.d.
Oil on canvas on board
9 × 12 inches
Signed LR
I.P. Stanback Museum and Planetarium, South Carolina State University, Orangeburg, South Carolina

Still Life, n.d.
Oil on composite board
11.5 × 13.5 inches
Signed LR
Fannie Etta and James T.L. Dandridge, Maryland

Stilt Walkers, n.d.
Oil on composite board
42 × 28 inches
Signed LL
Robert and Lillian Ross, New York

Three Kings (2), before 1954
Oil on composite board
36 × 24 inches
Signed LL
June and Walter Christmas, New York

Three Kings (1), c. 1950
Oil on composite board
30 × 16 inches
Signed LL
Robert and Lillian Ross, New York

To Market, Haitian Peasants, c. 1954
Oil on panel
22.5 × 28.75 inches
Signed LL
North Carolina Museum of Art, Raleigh, North Carolina

Tribal Scene, c. 1950
Oil on canvas
35 × 28 inches
Signed LL
Schomburg Center for Research in Black Culture, Art and Artifacts Division, New York Public Library; New York

Turpentine Farm, c. 1944
Oil
Unknown
Unknown
Private collection, New York

Two Mothers, Mothers with Children, On the Plantation, c. 1946
Oil on composite board
28 × 20 inches
Not signed
Howard University, Division of Fine Art, Washington, D.C.

Two Sisters, Sisters, c. 1945
Oil on composite board
30 × 24 inches
Signed LL
Robert and Lillian Ross, New York

Untitled, n.d.
Oil
Unknown
Not signed
Henry Phil Martin, New York

Untitled (three women standing), n.d.
Oil on composite board
38 × 19 inches (approximate)
Signed LL
Private collection, Florida

Untitled (fish in net), n.d.
Oil on composite board
9 × 12 inches
Signed LR
David Driskell, Maryland

Untitled (four Haitian women carrying pots), n.d.
Oil on composite board
25 × 21 inches
Unknown
Private collection, New York

Untitled (three Moroccan women), n.d.
Oil on canvas (?)
25 × 21 inches
Unknown
Private collection, New York

Warriors, c. 1950
Oil on canvas
30 × 25 inches
Signed LL
Hampton University Museum, Hampton, Virginia

Watermelon, n.d.
Oil on composite board
19 × 37 inches
Not signed
James Ligon and Dean Finke, New York

White Lilacs, before 1952
Oil on plywood
16 × 20 inches
Signed LR
James Ligon and Dean Finke, New York

Woman in a Red Dress, Girl in a Red Dress, c. 1944
Oil on composite board
24 × 18 inches
Signed LL
Aaron Douglas Collection, Amistad Research Center, Tulane University, New Orleans, Louisiana

Woman Sweeping, Sweeping, 1945
Oil on composite board
23.5 × 17.5 inches
Not signed
Harmon and Harriet Kelley Collection of African American Art, Texas

Women in Purdah, c. 1962
Oil on linen
29 × 20 inches
Signed LL
David King Dunaway, New Mexico

Women with Lanterns, Two Women with Lanterns, c. 1954
Oil on composite board
27.75 × 12.5 inches
Signed LL
I.P. Stanback Museum and Planetarium, South Carolina State University, Orangeburg, South Carolina

This list may contain duplicate works that are not paintings. Names and dates after listings indicate individual owners of works and the year of ownership. Full citations of printed sources appear in the bibliography.

Abbreviations

AAA	Archives of American Art
BBD	Cederholm, *Afro-American Artists*
CAC	Contemporary Arts Center catalogue
Fisk	Fisk catalogue
GP	Guggenheim Papers
SM	Speed Museum catalog

African Dancer, n.d. AAA

African Masks, before 1945. SM

African Princesses (seven women), before 1955. AAA; House and Garden, Aug. 1962; Mr. and Mrs. Henry McIntyre, Hillsborough, California, 1962

African Students, n.d. BBD

African Warrior, n.d. AAA

After the Flood, n.d. BBD

Alhambra, n.d. BBD

Along the Canal, before 1941. AAA

Altar Boy, before 1945. BBD

An Artist, before 1930. AAA; BBD

At the Band Saw, before 1943. BBD

At the Beach, Rockaway Beach, c. 1936. AAA

Autumn Bouquet, before 1948. SM

Bally-Hoo, before 1939. AAA

Bamboche, before 1954. AAA

Barber Shop, c. 1936. AAA

Beach Bathers, Bathers, Beach, before 1941. AAA; Cederholm

Beach Maiden, before 1946. AAA; GP

Beggars at Saut d'Eau, The Hunger Bitten, c. 1955. AAA

Bicycle Race, Cyclists, before 1930. AAA; Walter Hamilton, New York, New York, 1968

Bill Green, c. 1941, oil. AAA

Black Madonna and Child, c. 1940s, triptych. AAA

Blue Fish, before 1948. SM

Blues Singer, before 1941. AAA

Bosie Junior, n.d. Cederholm

Brothers, c. 1950. AAA

Brownstone in Winter, before 1945, oil. Cederholm

Caille, before 1954. AAA

Camion, after 1952. AAA; Eric Young, New York, New York, 1995

Carousel, before 1959. AAA; Mrs. Irene Ott, Toledo, Ohio, 1959

Charleston Sisters (two nuns), after 1944. Cederholm

Charleston, before 1948. AAA

Childplay, before 1959. AAA; Sanford D. Feirson, New York, New York, 1959

Children at Sundown, n.d. Cederholm

Children Skating, Girls Skating, Children at Play, before 1942. AAA; Mrs. Carol King, 1946

Chinese Kites, 1949, oil, 40 × 60 inches. Bearden and Henderson

Chloe, before 1942. GP

Combat, before 1948. CAC

Communion, before 1940. AAA

Composition in Reds (Haiti), c. 1952, oil. AAA

Conga, before 1942. GP

Cooling Cylinders, Cooling, before 1943. AAA

Dancers, before 1946. *Louisville Courier-Journal* article

Derelict, before 1950, oil. Clark Atlanta University catalogue, 1950

Diga-Diga-Doo, before 1939. AAA

Driftwood, n.d. Cederholm

Drill Press Hands, Press, before 1943, oil. GP

Drummer, n.d. AAA

Drying Nets, before 1948. SM

Easter, n.d. AAA

Ecole, before 1954. AAA

Edisto Family, before 1948. AAA

Entertainment, before 1938. AAA

Family Composition, Mother and Two Sons (Two

Peace, 1938. AAA

Peasant Dance, Haiti, c. 1954, oil. AAA

Peasants, n.d. Cederholm

Pension, n.d., signed LL. Cederholm

Picking Tobacco, South Carolina, c. 1944. AAA

Pigs with White Bands, n.d. Cederholm

Pigs, 1951-52. AAA

Pink Fish, c. 1947. Cederholm

Pink Vase, 1945, oil. AAA; Max Robinson, 1985

Plantation Life, after 1944. Cederholm

Porters, before 1943. GP

Priestess, before 1950, oil. Clark Atlanta University papers

Primative Fish, n.d. AAA

Rah Rah, n.d. Fisk

Reflections (1), c. 1936. AAA

Reflections (2), before 1939. GP

Repairing, n.d. Cederholm

Repairing Net, before 1947. SM

Reptiles, n.d. Cederholm

Riveting, before 1944. GP

Rocker, Old Rocker, before 1946, oil. AAA

Sailors, n.d. Cederholm

Saint Benedict the Moor, c. 1941-42, triptych. AAA

Self Portrait, c. 1930s. AAA

Skipping Rope, before 1952. AAA

Southern Fantasy, before 1946. Cederholm

Souvenir, n.d. Cederholm

St. Louis de Gonzegue, before 1954. AAA

Still Life, before 1933, signed LL. Harmon Catalogue, 1933

Strawberry, Corn and Squash, before 1944. AAA

Street Comber, n.d. AAA

Street Play, before 1948. Cederholm

Study of a Head, 1950, oil, 20 × 16 inches. AAA

Summer Bouquet, before 1948, signed LR. SM

Summer Magic, before 1946. Cederholm; Mrs. Carol King, 1946

Summer Play, before 1952, oil. Visual Arts Association (Louisville, Ky.) catalog, 1952

Sunday Morning Service, Mayfield, Ky. n.d. AAA

Sunday Picnic, before 1942. AAA

Sunshine, before 1948. AAA

Tiger Lilies, before 1946. AAA

Tobacco Patch, Mayfield, Kentucky, before 1939. AAA

Tresse Ruban, before 1954. AAA

Tropical Harvest, n.d., oil, 26 × 31.25 inches. Cederholm

Tropical Island, n.d. Cederholm

Two Alone, n.d. Cederholm

Unknown (female nude), n.d. AAA

Unknown (portrait), n.d. AAA

Unknown (still life with melons, bananas, and pineapple), n.d., signed LL. AAA

Unknown (women carrying sacks amongst pillars), before 1944. GP

Untitled (four Haitian women with bundles on heads), n.d., oil. Wilson papers, North Carolina Museum of Art; Mrs. T.J. Norman, Charlotte, North Carolina, 1971

Untitled (women vendors resting with sacks), n.d. D.P. Duckworth, Eric Young, New York, New York, 1995

Vendor (pink hut with vendor in blue shirt, chickens), c. 1950s. Senta Bier, *Louisville Courier-Journal*, 1950s

Victory Workers, Cylinder Boring, Filing Cylinders, before 1945. The joint board, Fur Dressers and Dyers Union CIO, 1945

Waiting, before 1948, oil. Clark-Atlanta University papers

Wash Day, Wash Day on the Barge, c. 1936. AAA

Watcher, before 1948. AAA

Watermelon Vendors, before 1939. Cederholm

Welding, before 1944. Cederholm

White Roses, c. 1937. AAA

Wild Geese, c. 1951. AAA

Women of Mozadara, n.d. AAA

Young Mother, before 1946. GP

BIBLIOGRAPHY

Against the Odds: African-American Artists and the Harmon Foundation. Newark: The Newark Museum, 1989.

Bearden, Romare, and Harry Henderson. *A History of African-American Artists from 1792 to the Present*. New York: Pantheon Books, 1993.

Bier, Justus. "Ellis Wilson: Kentucky Negro Artist." *Louisville Courier- Journal*. April 30, 1950.

Billops, Camille. Transcript of 1975 interview with Wilson. *Artist and Influence*. Vol. 13. New York: Hatch-Billops Archive, 1994.

Cederholm, Theresa B. *Afro-American Artists: A Bio-Bibliographical Directory*. Boston: Boston Public Library, 1973.

Contemporary Arts Center New York. Catalogue. June 14, 1948.

Dover, Cedric. *American Negro Art*. Greenwich, Conn.: The New York Graphic Society, 1960.

Driskell, David C. *Two Centuries of Black American Art*. New York: Knopf, 1976.

Duckworth, David P. "Ellis Wilson's Pursuit of a Theme on Labor." *International Review of African American Art* 9, no. 4: 41-49.

Fisk University. Exhibition catalogue. Paintings by Ellis Wilson, Ceramics and Sculpture by William E. Artis. Nashville: Carl Van Vechten Gallery of Fine Arts, April 18-June 2, 1971.

Lewis, Samella. *Art: African American*. Harcourt Brace Jovanovich, 1978.

Negro Artists: An Illustrated Review of their Achievements. New York: Harmon Foundation, 1935.

Ploski, Harry, and Warren Marr. *The Negro Almanac: A Reference Work on the Afro-American*. New York: Bellwether, 1976.

Riggs, Thomas. *St. James Guide to Black Artists*. Detroit, Mich.: St. James Press, 1997.

Speed Museum. Catalogue. 1948.

Thomison, Dennis. *The Black Artist in America*. Lanham, Md.: Scarecrow, 1991.

PHOTOGRAPHY CREDITS

Figure 3, property of the Division of Special Collections & Archives, University of Oregon Library System; plates 2, 13, Damian Andrus; plate 6, Michael Jay Smith; plates 7, 17, 27, Kenneth Hayden; plate 8, Ron Testa; plate 12, PhotoAssist; plate 22, Manu Sassoonian; plate 36, Wes Kent; plates 5, 10, 11, 15, 20, 21, 24–26, 28–34, 37–41, Albert Sperath.